# American Painting

# American Painting

edited by Francesca Castria Marchetti

Watson-Guptill Publications /
New York

*Front cover illustration:*
Edward Hopper, *Nighthawks*,
detail, 1943
Art Institute of Chicago

*Back cover illustration:*
Thomas Cole, *View from Mount Holyoke,
Northampton, Massachusetts, after a Thunderstorm
(The Oxbow)*, 1836
New York, The Metropolitan Museum of Art

*Frontispiece:*
George Caleb Bingham, *Fur Traders
Descending the Missouri*, detail, 1845
Metropolitan Museum of Art, New York

*Opposite:*
John Singer Sargent, *Portrait of Madame X
(Madame Gautreau)*, detail, 1882–84
Metropolitan Museum of Art, New York

*Following page:*
Grant Wood, *American Gothic*, detail, 1930
Art Institute of Chicago

*Page 6:*
Keith Haring, *Self-Portrait*, detail, 1985
Private collection, Milan

AMERICAN PAINTING
First published in the United States in 2003 by

WATSON-GUPTILL PUBLICATIONS,
a division of VNU Business Media, Inc.
770 Broadway, New York, NY 10003
www.watsonguptill.com

www.electaweb.it

English translation © 2002 by Mondadori
Electa spa, Milan
Translated by Jay Hyams

Library of Congress Control Number:
2002109819

ISBN: 0-8230-0331-0

Printed and bound in Italy

1 2 3 4 5 / 07 06 05 04 03

*Research of documentary sources*
Maria Vittoria Kelescian Giraldi

*Photograph credits*
Archivio Electa, Milan

*Thanks to the museums and private collections
that have provided photographic material,
in particular:*

Agence Photographique de la Réunion des
Musées Nationaux, Paris, photo Jean
Schormans
The Fine Arts Museums of San Francisco
Los Angeles County Museum of Art,
Los Angeles County Fund, Los Angeles
Tate Gallery, London
The Art Institute of Chicago
The New Britain Museum of American Art,
Connecticut, photo Michael Agee
The Metropolitan Museum of Art, New York
The Museum of Modern Art, New York
National Gallery of Art, Washington, D.C.
National Gallery of Canada, Ottawa
Whitney Museum of American Art, New York
Courtesy Thomas Ammann Fine Art, Zurich

Jean-Michel Basquiat, Thomas Hart Benton,
Willem de Kooning, Jim Dine, Lyonel
Feininger, Sam Francis, Jasper Johns, Franz
Kline, Roy Lichtenstein, Kenneth Noland,
Georgia O'Keeffe, Jackson Pollock, Robert
Rauschenberg, Man Ray, James Rosenquist,
Mark Rothko, Ben Shahn, Frank Stella, Mark
Tobey, Andy Warhol, Grant Wood © SIAE 2002

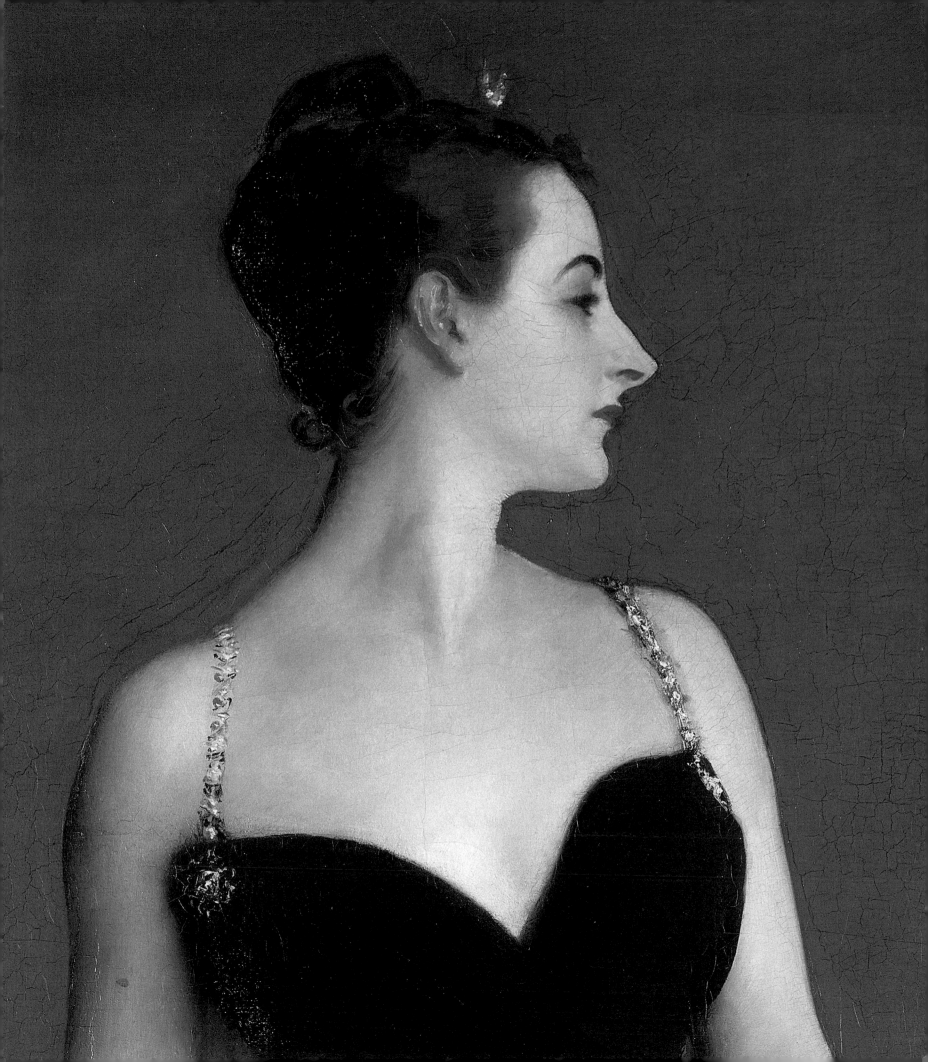

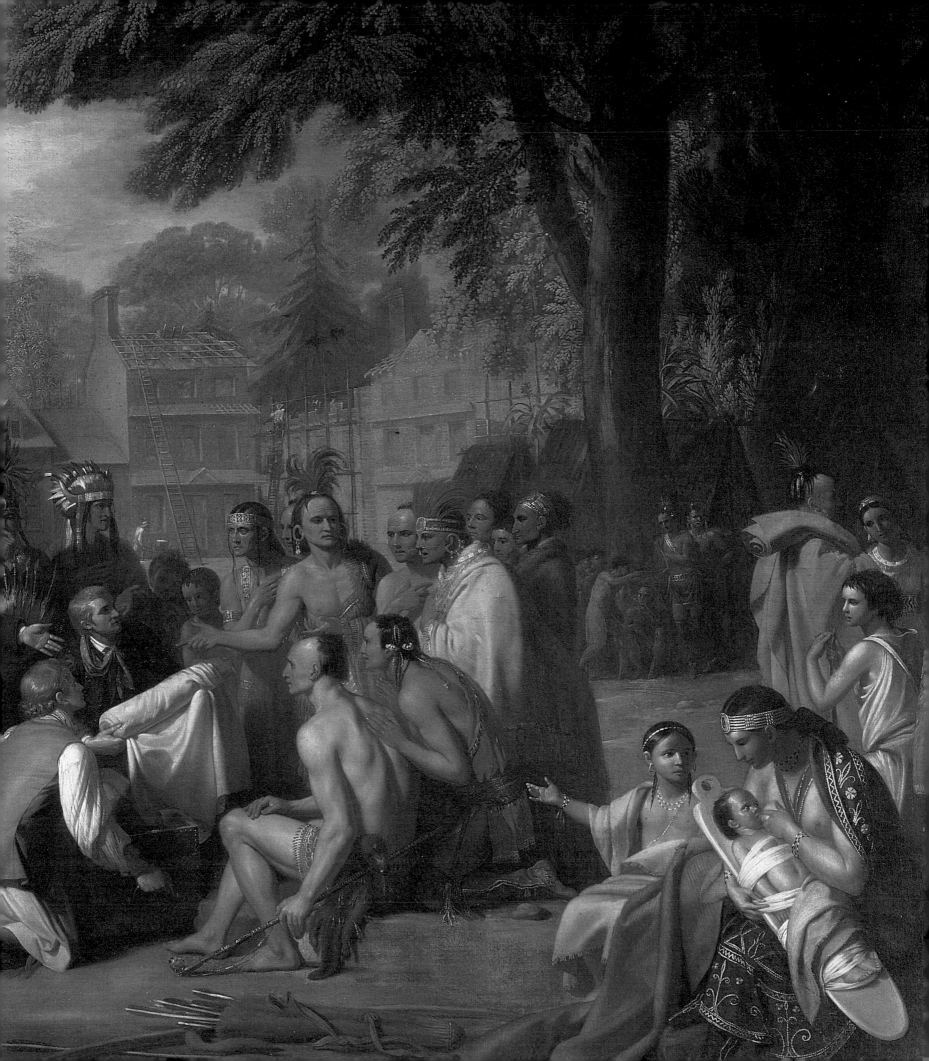

**Charles Willson Peale**
*The Staircase Group:*
*Raphaelle and Titian*
*Ramsay Peale*

1795
oil on canvas,
89.6 × 39.5
(227.7 × 100.3 cm)
Philadelphia Museum
of Art, Philadelphia

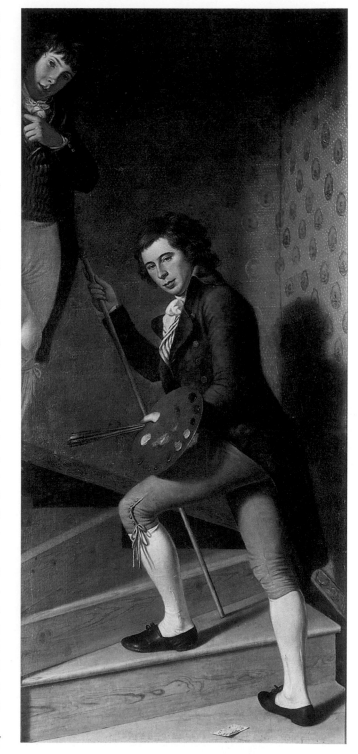

The period of the American Revolution was decisive in the history of American art. The 1770s saw the birth of an art that, while still influenced by the visual and mental concerns of the Old World, was more firmly anchored in the present. It aspired to make the most of contemporary reality while, in keeping with Enlightenment tradition, was determined to blend pragmatism with morality.

Since the earliest period of the nation's history, there was a widespread belief in the extraordinary cathartic power of art on individuals and on peoples, along with a belief in the close relationship between liberal arts and political liberty.

In truth, the characteristic feature of New World art eventually became the celebration of the most ordinary events of daily life. Strategies for fixing a scene in the present day and for presenting models of national virtues were blended in the works of Benjamin West, one of the first authentically American painters, who, having moved to London in 1763, became a major force in European culture, contributing to updating the tradition of history painting in the Old World.

Only with difficulty did English artists finally manage to free themselves from having to make portraits, a money-making necessity they saw as a form of condemnation. Such was not the case with their American counterparts, who early on emancipated themselves from portraiture and moved on to the more demanding *grand genre* of history painting.

The custom that called for a history painting to be bathed in an aura of antiquity was, of course, unacceptable to a pragmatic and enterprising society free of historical memory. All the same, the Americans saw no reason why they should do without a cultural identity of their own. West's *The Death of General Wolfe,* definitely the first great epic work in modern dress, thus represents an important step in the break with tradition.

John Singleton Copley, a student and friend of West's, went even further, introducing minor themes and even personal life histories into the formerly ex-

**John Vanderlyn**
*Marius amid the Ruins at Carthage*

1807
oil on canvas, 87 × 68.5
(221 × 174 cm)
Fine Arts Museums
of San Francisco

**John Singleton Copley**
*Mrs. Humphrey Devereux*

1771
oil on canvas, 40.2 × 32.1
(102 × 81.5 cm)
National Art Gallery,
Wellington, New Zealand

clusive precincts of the *grand genre*. In his painting *Watson and the Shark* Copley transformed a scene from ordinary contemporary life—a young man falls in the water, is attacked by a shark, and then is saved by a group of sailors—into a work of great emotional breadth in which the ferocious animal attacking the innocent youth takes on the force of a biblical narrative.

The version of "history in the present" created by West and Copley was immediately taken up by other artists; there are, for example, the many scenes of events in the American Revolution by John Trumbull, along with the works of John Vanderlyn. The acquisition of artistic self-sufficiency, free from the figurative culture of Europe (which remained, however, an inescapable source of new ideas), permitted the creation of a national school, the development of which was supported by a solid network of institutions.

When the first American museums were planned,

they were based on the example of the Louvre in Paris, but the most authoritative model behind them was that of the galleries connected to European academies, like the Royal Academy in London, where, alongside collections of grand masters, works by contemporary artists were displayed.

In 1802, the American Academy of Fine Arts was founded in New York, joined in 1825 by the National Academy of Design, an alternative institution directed by artists themselves, with a school and annual exhibitions.

Along with New York there were two other major centers of cultural tradition, actively protecting and encouraging the arts: Boston, with its Atheneum, and Philadelphia, with the Pennsylvania Academy of Fine Arts. Among that institution's founders was Charles Willson Peale, a versatile artist who was West's first American student in London.

# Benjamin West

*Springfield, Pennsylvania, 1738–
London, 1820*

An American transplanted to Europe,
it was West who introduced the new
type of history painting using
contemporary subjects. After three
years (1760–63) of study in Italy,
where he was inspired by exposure
to the circle of Johann Winckelmann,
West set himself up in London,
working initially as a portraitist but
then dedicating himself to subjects of
ancient history. He found favor at the
court of George III, who commissioned
a series of religious paintings from him
(never completed) on themes from
the Old and New Testaments,
suitably modified to meet Protestant
requirements. Later he took on subjects
of contemporary events and modern
customs, but he treated them in neo-
fifteenth-century and baroque style.
*The Death of General Wolfe* and *Penn's
Treaty with the Indians* are typical
examples of this new genre, in which
the real and the ideal were blended
according to classical style, most of all
the style of Poussin. At the death of
Sir Joshua Reynolds, in 1792, West was
elected second president of the Royal
Academy of London (founded in
1768). His later works have a more
personal tone and are interesting for
their suggestions of the romantic
theories of Edmund Burke, with his
notions of the concept of the sublime.

**Benjamin West**
*Portrait of Colonel Guy Johnson
and Karonghyontye
(Captain David Hill)*

1776
oil on canvas, 79.5 × 54.3
(202 × 138 cm)
National Gallery of Art,
Washington, D.C.

West's adherence to neoclassical
canons of art is readily apparent
in this portrait of Guy Johnson,
an English colonel serving as
superintendent of Indian affairs
in America. Standing in the
shadow behind Johnson is his
close friend Karonghyontye,
a Mohawk chief who acted as
Johnson's assistant and war
counselor. The highly stylized
figure of the Indian is the
fulcrum of the painting, serving
to connect the Englishman to the
background scene at the far left,
showing an Indian encampment
at the feet of a waterfall (almost
certainly Niagara). West invests
certain details with great
evocative power, such as the
musket held by the colonel
and the pipe held by the chief,
possessions symbolic of their
different civilizations.

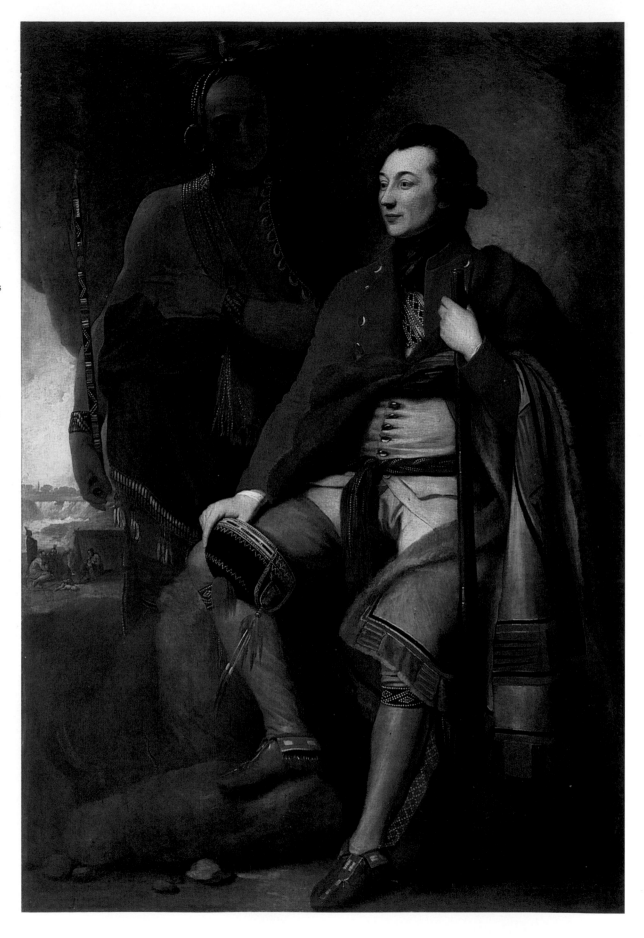

**John Singleton Copley**
*Paul Revere*

c. 1768–70
oil on canvas, 35 × 28.5
(89 × 72.3 cm)
Museum of Fine Arts,
Boston

The classical layout and
Titianesque mood contrast
with the realism of the
scene. Revere, the famous
patriot and silversmith,
seems to have been taken
by surprise while busy
at his worktable, the
evocation of daily
labor supported by the
disorderly array of tools
on the table. The intense
expression on his face
and the calm strength of
his pose testify to Copley's
efforts to bring to
the surface signs of his
inner spirit.

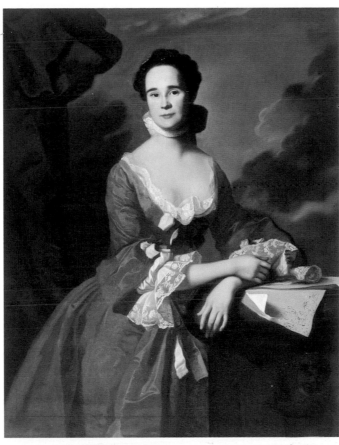

**John Singleton Copley**
*Mary Green Hubbard*

1764
oil on canvas, 50.2 × 39.8
(127.6 × 101 cm)
Art Institute of Chicago

**John Singleton Copley**
*The Copley Family*

1776-77
oil on canvas, 72.6 × 90.6
(184.4 × 230 cm)
National Gallery of Art,
Washington, D.C.

Made after the artist's
move to London, this
work shows the influence
of Reynolds in the
progressive abandonment
of the linear style Copley
had previously used to
define figures and drapery,
replaced by freer and also
softer brushstrokes.
The influence of Reynolds
is also evident in the
arrangement of the figures,
posed in accordance with
the iconography of the
high style of seventeenth-
century Italian painting.
The mother-and-children
group shows clear
influences of Holy Family
scenes by Guido Reni and
Jacopo da Pontormo, while
the self-portrait recalls the
style of Pompeo Batoni,
an Italian portrait painter
much in vogue in England
at the time.

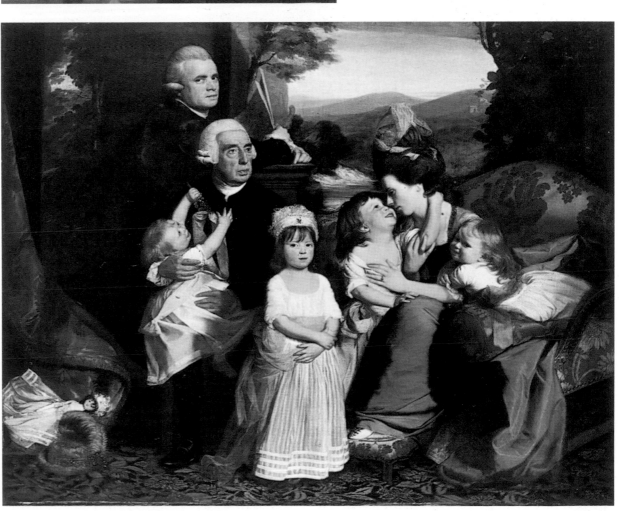

**John Singleton Copley**
*The Death of Major Peirson*

1782-84
oil on canvas,
98.8 × 143.7
(251 × 365 cm)
Tate Gallery, London

Just as the American
colonies were about to
wrest their freedom from
the mother country, the
English were gladdened
by their victory against
the French for possession
of the island of Jersey.
Copley presents the
culminating moment of
the battle, on January 6,
1781, when, following
the death of Major Francis
Peirson, depicted at the
center of the painting,
the English put to fire
and sword the main square
of the capital city, Saint
Helier, where a statue
of George II stands in
triumph amid the smoke
and banners.

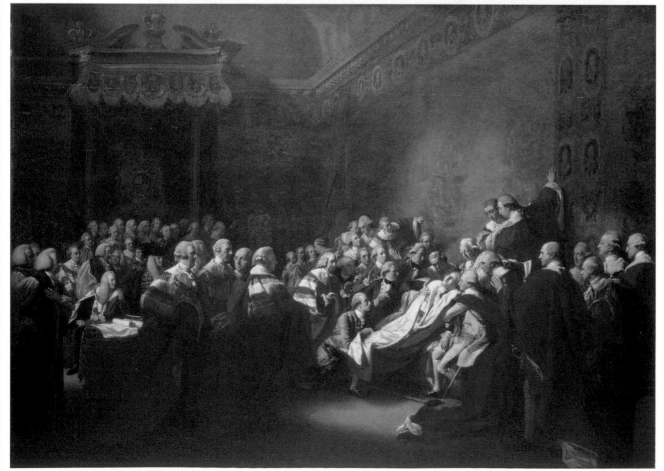

**John Singleton Copley**
*The Collapse of
the Earl of Chatham
in the House of Lords*

1779-80
oil on canvas,
89.8 × 120.9
(228 × 307 cm)
Tate Gallery, London

The painting shows
the collapse of Chatham
(he died later), after
giving a speech in the
House of Lords on July 7,
1778, in which he urged
conciliation with the
American colonies.
In repeating a theme
already treated by West
the previous year,
Copley took the "realist
revolution" inaugurated
by West and brought it
ahead several steps:
His version of realism
goes further, including
in the scene authentic
portraits of the men
who actually witnessed
the historic event.

**John Singleton Copley**
*Three Daughters of George III*

1785
oil on canvas,
104.7 × 73.2
(266 × 186 cm)
Collection of Her Majesty
the Queen

**John Vanderlyn**
*The Death of Jane McCrea*

1804
oil on canvas, 35.9 × 26.5
(91.2 × 67.3 cm)
Wadsworth Atheneum,
Hartford, Connecticut

The subject, a notorious
episode from the American
Revolution, is the murder
(and scalping) of a young
girl, an event that became
a rallying point for the
rebel cause. Vanderlyn
uses this tragic theme as
the basis for a visual poem
on the subjects of ferocity,
primitive peoples, and
heroism, all of it presented
with a combination of
drama and monumentality.
The influence of David
is quite strong in the
painting, both in the
balanced distribution
of the composition and in
the figures, which present
clear similarities to David's
*Oath of the Horatii* and *Rape
of the Sabine Women*.

**John Vanderlyn**
*Ariadne Asleep
on the Island of Naxos*

1814
oil on canvas, 68 × 87
(172.7 × 221 cm)
Pennsylvania Academy
of Fine Arts, Philadelphia

Painted in Paris, this work
met critical success when
presented at the Salon of
1812. Ten years later, put
on display in New York
alongside copies of Titian's
*Danaë* and Correggio's
*Antiope*, it offended Puritan
sensibilities. Its American
viewers did not appreciate
Vanderlyn's abundant
concessions to French-style
ideals of beauty, but
it was primarily the nudity
that caused the scandal.
Vanderlyn's career
thus began the decline
from which it would
never recover.

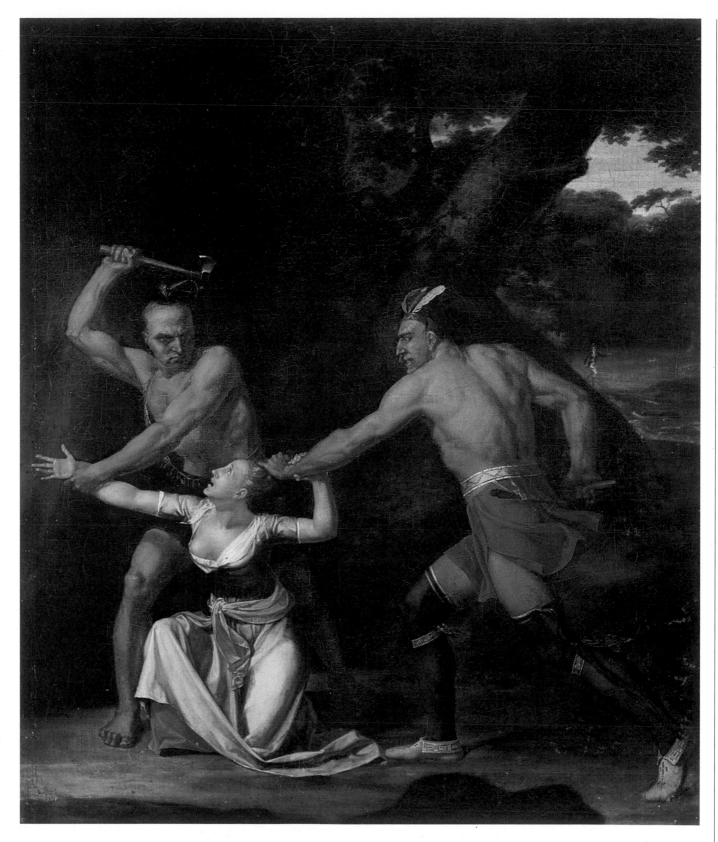

# The discovery of the West

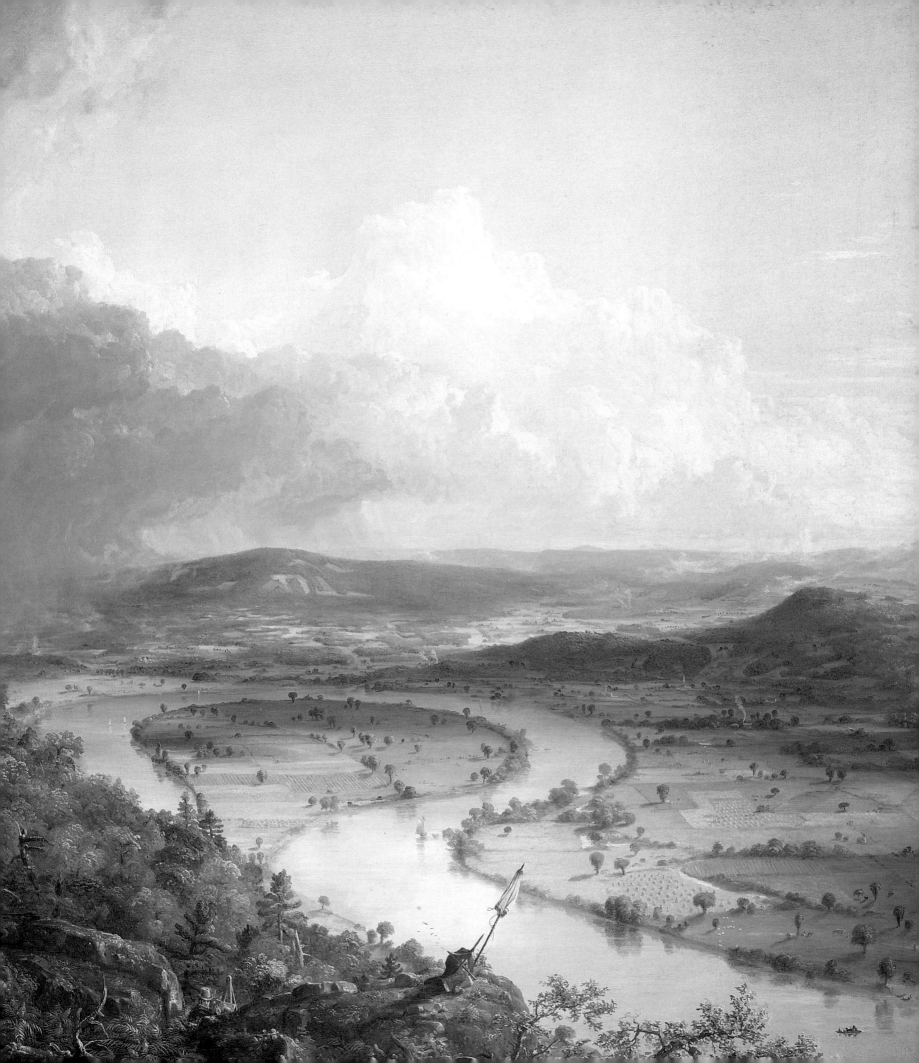

**Asher B. Durand**
*Rocky Cliff*

c. 1860
oil on canvas, 16.5 × 24
(42 × 61 cm)
Reynolda House,
Museum of American Art,
Winston-Salem,
North Carolina

Durand's paintings are
accumulations of detail,
meticulously presented in
the belief that the beauty
of nature is visible in even
its smallest fragment.

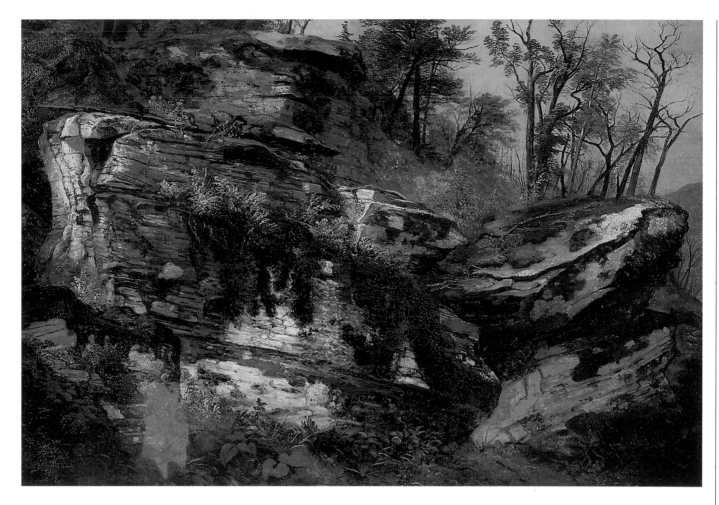

**Asher B. Durand**
*Kaaterskill Clove*

1866
oil on canvas, 38.3 × 60
(97.2 × 152.4 cm)
Century Association,
New York City

Similar landscape vistas
appear so often in the
canvases of American
artists that they can be
taken as an icon of their
painting. The aerial
perspective, the gradations
of light, the slopes of
the mountains all come
together to create a scenic
vision that is both majestic
and intimate: In the heart
of the Catskill Mountains
is a large gorge draped
in green vegetation and
cut by a river running
west to east.

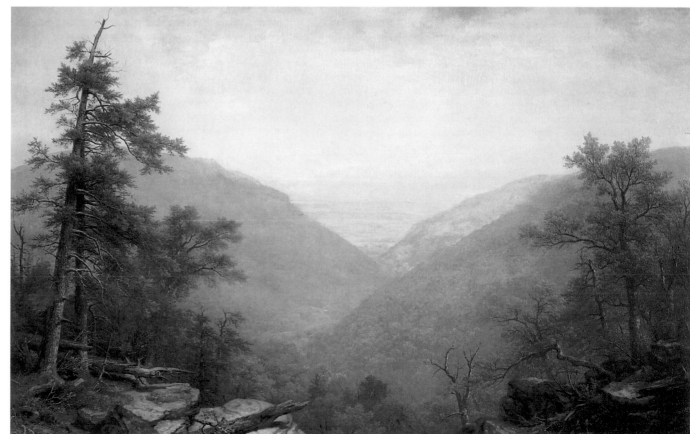

# Albert Bierstadt

*Solingen, Germany, 1830–New York, 1902*

Bierstadt was born in Germany and arrived in America with his family when only two years old to settle in New Bedford, Massachusetts. It was only following a trip back to Europe, however, that his artistic style matured. In 1853 he went to study at Düsseldorf, the principal European city at that time for the training of young American artists, and he stayed there for four years. During this European stay he made several trips to Switzerland and Italy, in both countries making a great number of sketches that, back in America, served as inspiration for the creation of some of his largest works. The actual sites of his landscapes cannot be identified, since any topographical identity has been obliterated by the process of idealizing reality; references to the Swiss Alps appear in immense views of mountain ranges in the American West, works that often involve the repetition of compositional elements. His complicated images display an unequaled technical skill that earned him fame as one of the leading landscape artists of his time. Starting at the end of the 1850s Bierstadt began to explore the American West, taking part in exploratory expeditions. During these trips he portrayed the still unspoiled wonders of the Rocky Mountains and the Sierra Nevada. At the height of his fame, in 1863, Bierstadt traveled into the fastnesses of the California mountains, where he was astonished by the beauty of Yosemite Valley, an area compared to the Garden of Eden by the first explorers to see it, in 1855. Bierstadt spent seven weeks working in the valley in direct contact with nature, and thus was the first artist to paint this wonderful setting. The rock walls towering like cathedrals over the plain, the meandering river, and the ever-changing sky offered Bierstadt natural themes of extreme beauty, and he took it all in and amplified it. Bierstadt offered Americans a sense of wonder at their own homeland, and the public and critics embraced his works with enthusiasm, thrilled by their scale and detail. However, as early as the end of the 1870s, a change in attitude came over both American artists and collectors, who no longer recognized themselves in the version of the national spirit promoted by the work of Bierstadt, and he, at the height of his career, found himself practically forgotten.

**Albert Bierstadt**
*Sunrise, Yosemite Valley*

c. 1870
oil on canvas, 36.5 × 52.4 (92.8 × 133 cm)
Amon Carter Museum, Fort Worth, Texas

With the discovery of gold in California in 1848, westward expansion rushed ahead; in 1855 the Yosemite Valley was explored, bringing to light its extraordinary beauty protected by the rocky walls of the Sierra Nevada. Bierstadt, taking part in an expedition of geographical exploration, arrived in the valley in 1863 and, enthralled by the spectacular scenery, camped there for seven weeks.

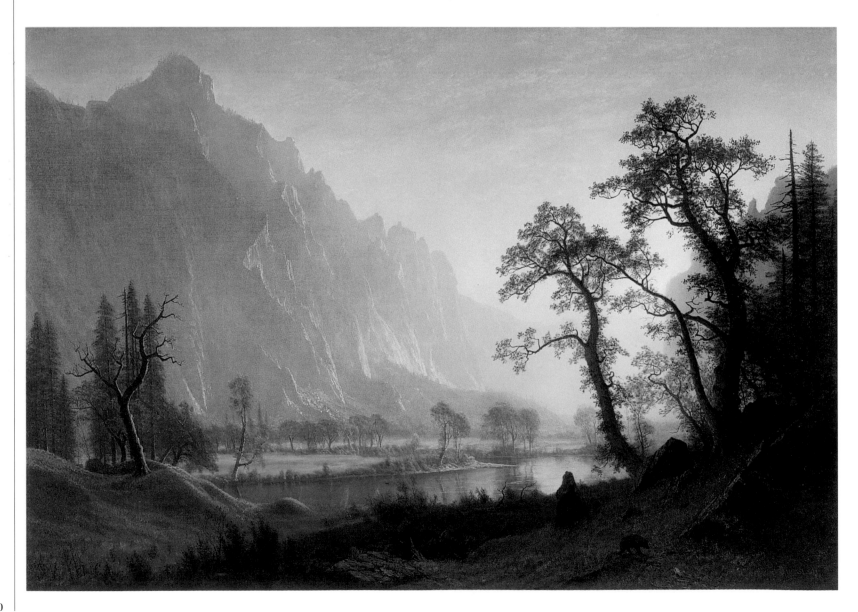

**Albert Bierstadt**
*On the Merced River*

c. 1863
oil on canvas, 36.5 × 52.5
(92.7 × 133.4 cm)
California Historical
Society, San Francisco

Bierstadt joins reality to
fantasy, often using the
same compositional
element in more than one
landscape, such as the
detail of pine trees in the
foreground, some green,
others leafless, standing
out against the backdrop
of distant mountains.

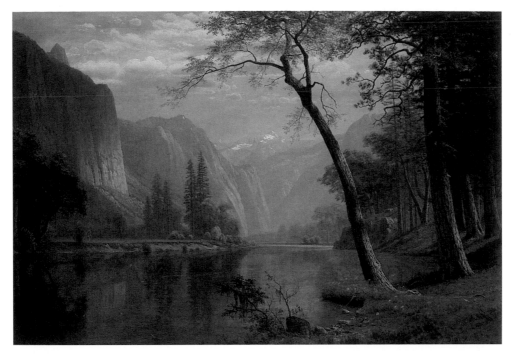

**Albert Bierstadt**
*Looking Up the Yosemite Valley*

c. 1863–65
oil on canvas, 40 × 58.5
(91.4 × 148.6 cm)
Haggin Museum,
Stockton, California

Under a partly cloudy sky,
the rocky walls of the
valley glow in the light
of late summer. The plain
in the foreground is filled
with a clear shadow, while
the Merced River winds
its way slowly across
the middle ground.

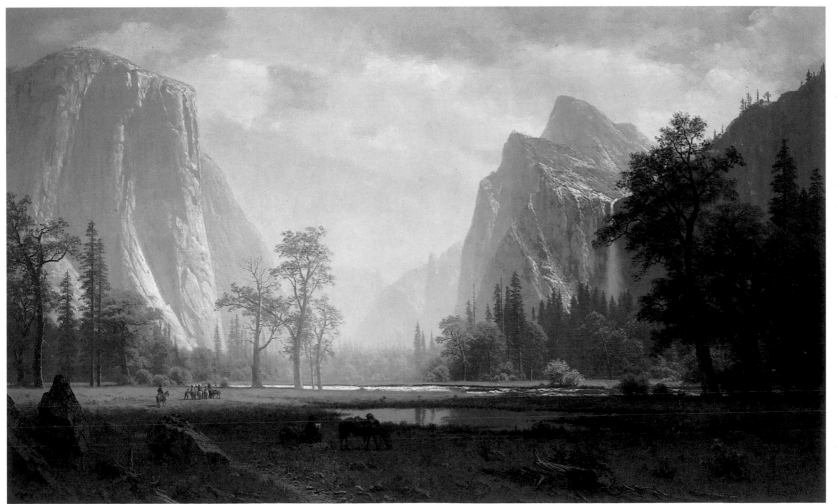

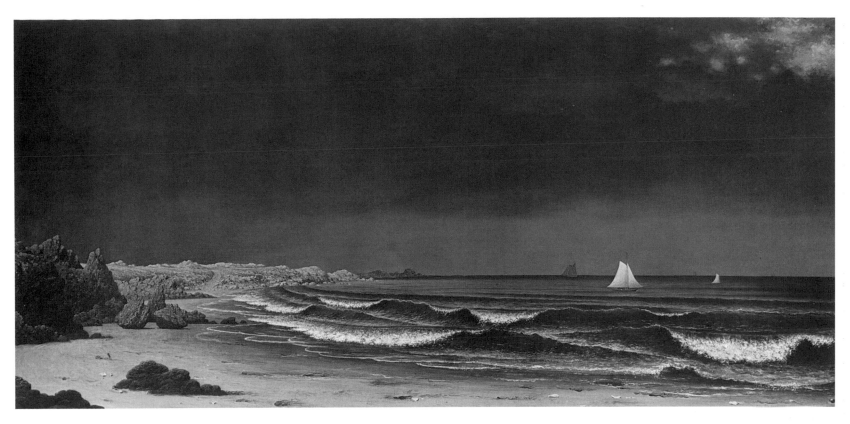

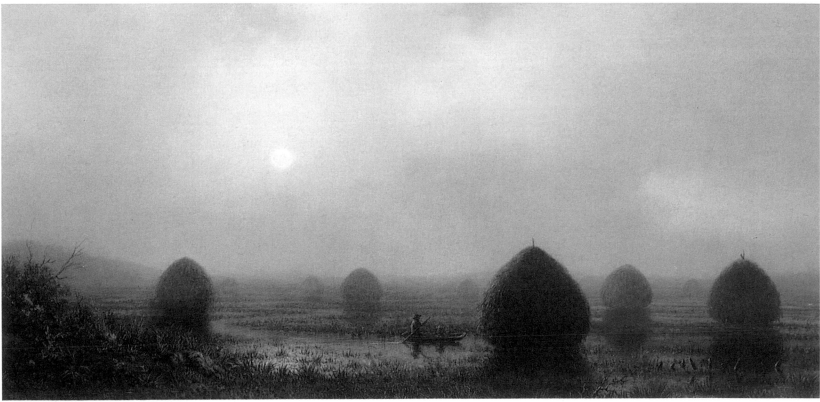

**Martin Johnson Heade**
*Approaching Storm,*
*Beach near Newport*

c. 1866–67
oil on canvas, 28 × 58.3
(71 × 148 cm)
Museum of Fine Arts,
Boston

The narrow horizontal
format in which the broad
curving swath of a beach
cuts obliquely across
the composition is a
recurrent element in
paintings by Heade.
In this case, the movement
of the waves guides the
viewer's eyes from

the water's edge at the left,
out over the water toward
the small ships visible
to the right.

**Martin Heade**
*The Great Swamp*

1868
oil on canvas, 14.8 × 30.1
(37.7 × 76.5 cm)
Fine Arts Museums
of San Francisco

In 1862 Heade began
to explore a new
theme—salt marshes.
He continued with
them for more than thirty
years. With its sharply
horizontal format, this
composition is broken off
by the row of haystacks,
the sinuous arrangement

of which leads the viewer's
eyes from the small boat
in the foreground out
to where the farthest
haystacks vanish
in the distance.

**Martin Johnson Heade**
*Brazilian Forest*

1864
oil on canvas, 20.1 × 16
(51 × 40.6 cm)
Museum of Art,
Providence, Rhode Island

In 1864 Heade was named
a knight of the Order of
the Rose by Dom Pedro II,
emperor of Brazil, in
recognition of his paintings
with Brazilian settings.

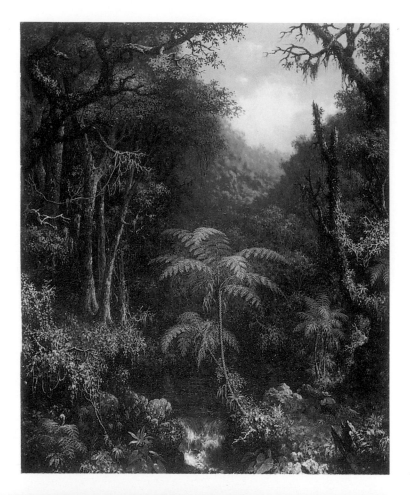

**Martin Johnson Heade**
*View from Fern-Tree Walk,
Jamaica*

c. 1870
oil on canvas, 53 × 90
(134.6 × 228.6 cm)
Hirschl and Adler
Galleries, New York

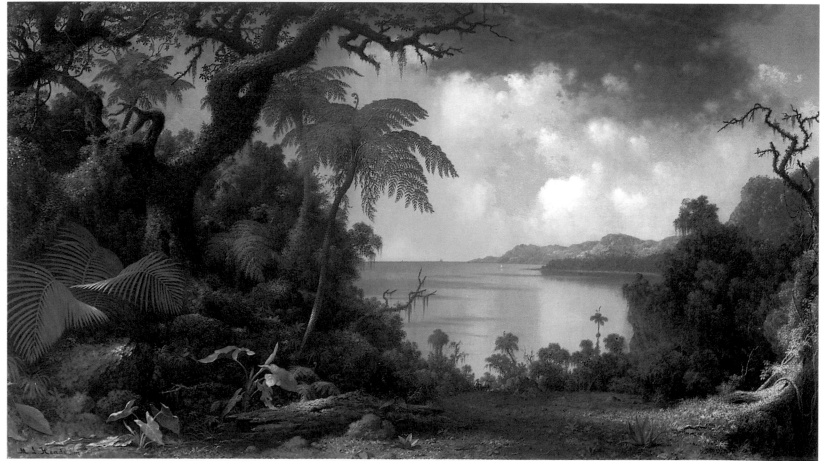

**Martin Johnson Heade**
*Orchids and Hummingbird*

1880
oil on canvas, 20.1 × 14.2
(51 × 36 cm)
Collection of Mr. and Mrs.
Robert C. Graham,
New York

Heade is known not only
for his landscapes but
for a highly original
series of works featuring
hummingbirds and orchids
in the tropical forests of
Brazil. Intrigued by the
compositional possibilities
suggested by photography,
Heade reinforces the
viewer's involvement
in the scene by bringing
the foreground into
exaggerated focus, much
like what happens when
a photograph is taken at
extremely close range.
By eliminating the
elements that might
connect the flower to
the bird or the foreground
scene to the depth behind
it, Heade emphasizes
the size of the orchid
in the foreground, as
compared to the equatorial
forest behind it, which
barely emerges from
the steamy haze.

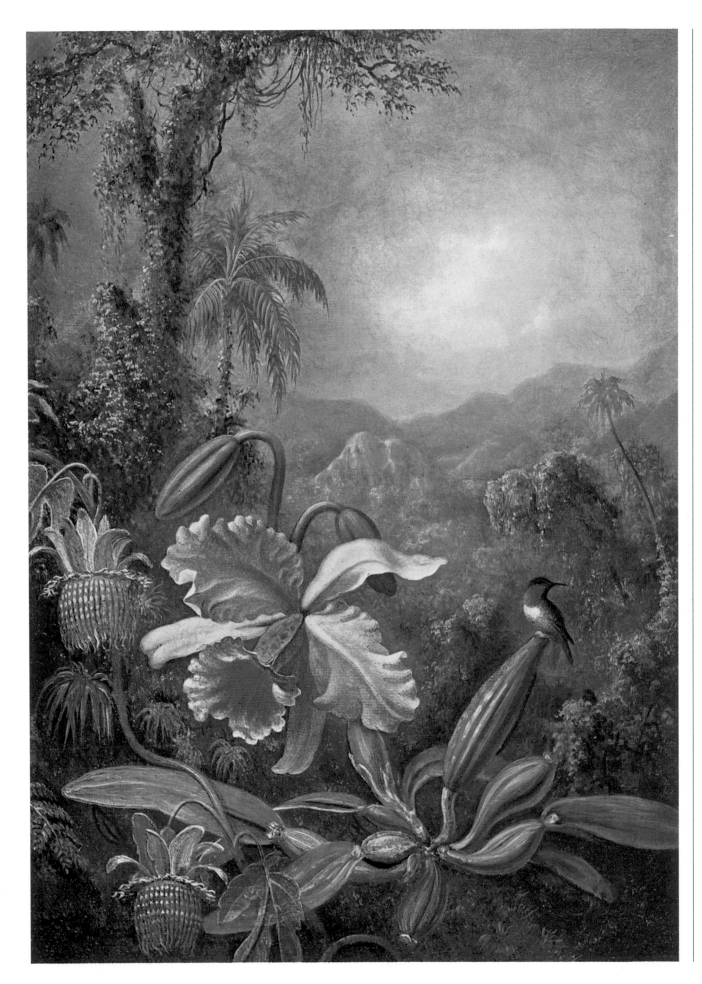

During the second half of the nineteenth century, the young United States faced serious questions concerning its identity and singularity. Manifest destiny, the belief that the nation's fate is to expand its territory and to extend its influence worldwide, comes up hard against the threat of a nation divided in struggle between North and South. During this period of enormous change, American painting went through a season in which the special traits of an "American" art came to be defined with greater clarity. It is an art that mirrors a nation and a culture that have finally broken their ties to the Old World.

There is nothing easy about the break, however. The social elite in the wealthy cities still feel themselves connected to the world that sips afternoon tea in London, makes the rounds of art galleries in Paris, takes a room with a view in Florence.

In paintings, this Eurocentrism is expressed in the works of American artists who emulate French Impressionism; their leading opponents are such realist painters as Winslow Homer and Thomas Eakins. Both artists are men of great awareness, culturally up to date; for them, the rejection of French styles is part of a distinct point of view, another way in which they try to present the vitality and force of nature and reality.

Homer made his debut as an "artist-correspondent," creating images of the Civil War. The painting reproduced on the preceding pages, *Prisoners from the Front,* became so famous that it was selected to represent American painting at the Universal Exhibition in Paris in 1867. With its approach to its subject, monumental without being rhetorical, it stands as an outstanding example of Homer's grand style. Eakins, on the other hand, developed from medical-scientif-

**Winslow Homer**
*The Fog Warning*

1885
oil on canvas, 29.9 × 48
(76 × 122 cm)
Museum of Fine Arts,
Boston

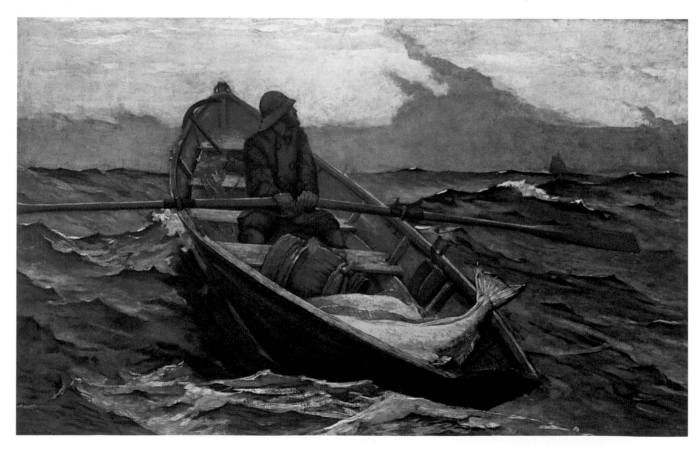

**Thomas Eakins**
*The Dean's Roll Call*

1899
oil on canvas, 83.9 × 41.7
(213 × 106 cm)
Museum of Fine Arts,
Boston

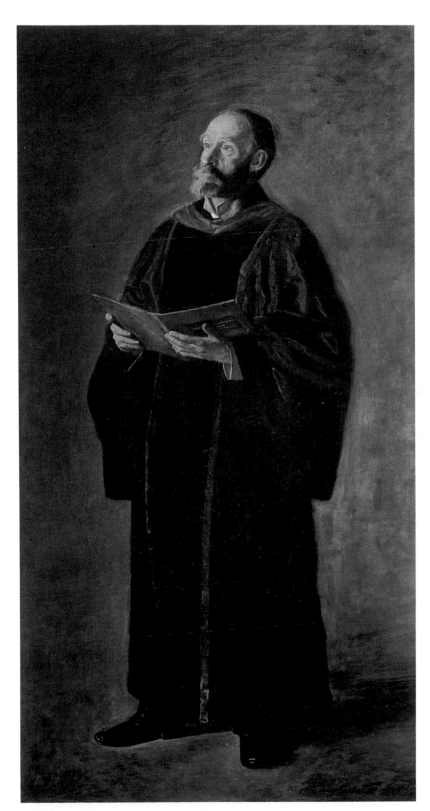

ic studies to present lucid images of reality, along
with intensely believable portraits.

The nineteenth century was the progressive
westward movement of the frontier continued. From
the Gold Rush in Alaska, to the conquest of territo-
ries once among the dominions of Spain, the push
went on until Americans were gazing out across the
Pacific Ocean. Despite the harrowing ordeal of the
Civil War, the nation's western expansion was con-
stant. "Go west, young man"; but as the borders of
federal administration expanded outward, the
crowds headed for the frontier and the towns of the
Wild West came to include poor immigrants.

In the often traumatic encounter between the pi-
oneers and a new, unknown land, a new epic came in-
to being, one in which the "white man" took the roles
of narrator, protagonist, and judge. The idyllic con-
templation of the fabulous natural beauty of the
American Eden, celebrated by the landscape artists
of the early nineteenth century, was replaced by a
more compelling but also more dangerous environ-
mental and human drama, one whose pictorial ex-
pression called for a strong narrative voice.

The myths of the West find their most memorable
interpreter in Frederic Remington, painter of cow-
boys and cavalrymen. He made most of his paintings
on the brink of the twentieth century, by which time
the epic was really almost over: the Native Americans
were enclosed in reservations and herds of buffalo no
longer covered the prairie. A similar sense of loss at-
taches to the objects that appear in the masterful
trompe l'oeil works of William Michael Harnett and
John Frederick Peto. These works, which present ob-
jects of daily life from a time not so far gone, come to
us wrapped in a mantle of nostalgia that only adds to
their sense of astonishing artifice. Remington was also
the creator of wonderful bronze statues of the anony-
mous, dusty heroes of the West. Proudly displayed on
office desks and in company meeting rooms nation-
wide, they present exemplary images of the champi-
ons of a new, rowdy, and generous "Americanness."

# Thomas Eakins

*Philadelphia, 1844–1916*

Openly opposed to the stylish habit among many of his colleagues of moving to Europe, Thomas Eakins represents, together with Homer, the most direct and intense version of American realism at the end of the nineteenth century. Born into a well-to-do middle-class family, and thus relieved of any financial preoccupations, Eakins created for a select few people, primarily intellectuals, to whom his paintings offered a radical alternative to the aesthetic elegance of John Singer Sargent and the painters tied to Impressionism. After studies at the Philadelphia Academy of Fine Arts, and also after following a course in medicine, Eakins did, however, spend a period in Paris, where he encountered and highly esteemed Manet. From 1873 on, he remained in Philadelphia, where the controversial *Surgical Clinic of Professor Gross* (1875) earned him much fame. As a realist painter, Eakins affirmed the necessity of understanding and studying reality, including by way of science and the advances in the field of photography, but without any sprinkling of European culture dust. "Nature," he wrote, "is just as varied and just as beautiful in our day as she was in the time of Phidias." He began a collaboration with the photographer Eadweard Muybridge in 1884, and under the auspices of the University of Pennsylvania, he assembled a large collection of images of human and animal locomotion, published in 1887 as *Animal Locomotion*, a spectacular volume illustrated by more than seven hundred images arranged in sequence. This scientific attitude directed his career as a painter, free of the usual conventions, including any need to please the public. Public exhibitions of Eakins's works were rare and invariably controversial; he preferred smaller shows, at which he sought the approval of a limited circle of intellectuals, the same people who posed for his portraits, from university professors to the poet Walt Whitman. Only at the posthumous show held in New York in 1917 did American artists, and in particular the members of the Eight, discover the importance, commitment, and solid concision of his noncelebratory realism.

**Thomas Eakins**
*Portrait of Frank Jay
Saint John*

1900
oil on canvas, 23.6 × 19.7
(60 × 50 cm)
Fine Arts Museums
of San Francisco

In portraits, too, Eakins revealed his desire to be free of European schematics, seeking to be faithful to the truth instead.

**Thomas Eakins**
*The Surgical Clinic
of Professor Gross*

1875
oil on canvas, 96.1 × 78
(244 × 198 cm)
Thomas Jefferson
University Art Museum,
Philadelphia

This is Eakins's best-known work, commissioned to celebrate the famous surgeon Samuel Gross; in it Eakins does not limit himself to making a portrait of the professor but instead locates him in the dramatic and disturbing setting of an operation being carried out in public in the anatomy theater of Jefferson Medical Hospital, where Eakins himself had studied. Rejected by the judges of the artistic commission for the large show for the 1876 Centennial Exposition in Philadelphia, the work was presented to the public in the section reserved for medicine, where its immediate and brutal realism awakened lively reactions, among them nausea and fainting.

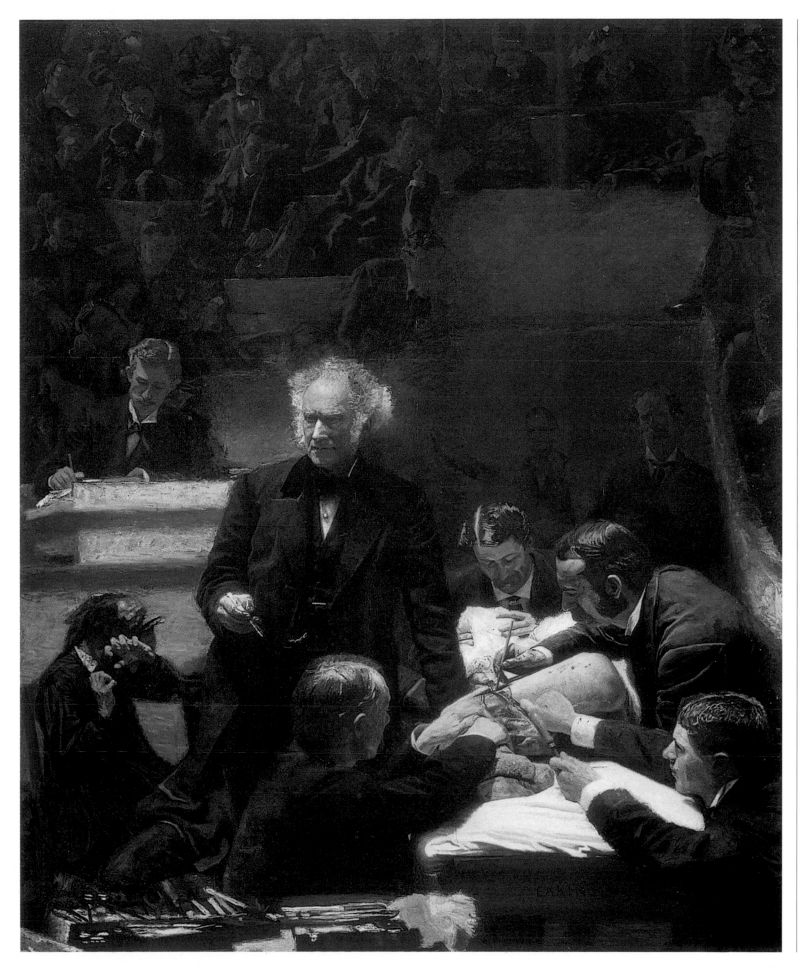

**John Frederick Peto**
*Job Lot Cheap*

1892
oil on canvas, 30 × 40.2
(76.2 × 102 cm)
Fine Arts Museums
of San Francisco

This important canvas
dates to the mature phase
of Peto's production,
by which time he had
moved to New Jersey.
It can be interpreted as a
metaphor for the decline
of the genre of the still life

itself. In Island Heights,
Peto exhibited his works
in the town grocery store,
offering them for sale to
tourists and passersby
much like the old books
heaped haphazardly onto
the shelf in this painting.
The dark tones and
shadowy depth are quite
rare for Peto, who seems
to have decided to break
with the wooden-plank
background that is
characteristic of so
much of his production.

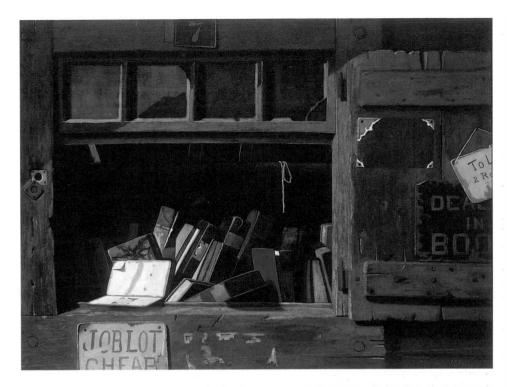

**John Frederick Peto**
*The Cup We All Race 4*

c. 1900
oil on canvas, 24.6 × 20.7
(62.5 × 52.6 cm)
Fine Arts Museums
of San Francisco

John Frederick Peto often
used the trick of simulating
writing carved with the
tip of a knife blade into
the imaginary wooden
backgrounds of his
paintings, and such graffiti
very often became the
titles of his works. Planks
or doors—dented,
faded, cracked—serve as
backgrounds against which
objects of various materials,
rendered with virtuosic
illusionism, stand out,
sharply defined by light.
The outward extension of
the objects is balanced by
cracks and scratches in the
background, suggesting
varying planes of depth.

# Frederic Remington

*Canton, New York, 1861–*
*Ridgefield, Connecticut, 1909*

Painter and sculptor of exceptionally popular success, Frederic Remington was the bard of the West. Many directors of western movies proudly acknowledge having drawn inspiration from his works; John Ford himself cites a Remington painting in a famous sequence in *Stagecoach*, one of the masterpieces of the genre. Remington had a solid classical education, including art studies at Yale, and although he made only one trip to Europe, late in life and in a hurried manner, he kept up to date on Old World artistic trends. Such considerations are indispensable to any understanding of Remington's special style, apparently so inspired by immediate, even "photographic" experience, but in reality the result of thorough skills and a great deal of preparation.

Although he was born on the East Coast and spent his childhood there, Remington felt the call of the frontier and made his first trip west, to Montana, in 1881, at the age of twenty. The next year he began contributing to the leading periodicals of the day, such as *Harper's Weekly* and *Century Illustrated Magazine*. He soon developed a singular style, with images of striking visual impact using primarily pale colors. Over the course of the next decade he alternated trips to the West—during which he made sketches from life to later work into paintings and sculptures—with activity as a popular writer and illustrator of books. His fame received a further boost in 1901 when nationally popular periodicals began printing full-color, double-page reproductions of his paintings. Remington was and is acclaimed as the witness to an adventure shared by all Americans, as Theodore Roosevelt acknowledged in a commemorative speech given a year after the artist's

death. Although praised by the public and critics, who enthusiastically ranked him among the greatest of all American artists, Remington felt a growing melancholy during the last years of his life. Just before his fortieth birthday, he lamented, "My West passed out of existence so long ago as to make it merely a dream." Only eight years later he died of appendicitis.

**Frederic Remington**
*Dismounted: The Fourth*
*Troopers Moving*
*the Led Horses*

1890
oil on canvas,
34.1 × 48.8
(86.5 × 124 cm)
Sterling and Francine
Clark Art Institute,
Williamstown,
Massachusetts

Remington reached the heights of his celebrity with dramatic, crowded, action-packed scenes that today seem like painted photographs, while the canvases with only a few, solitary figures have more of a sense of melancholy for a world on the verge of ending.

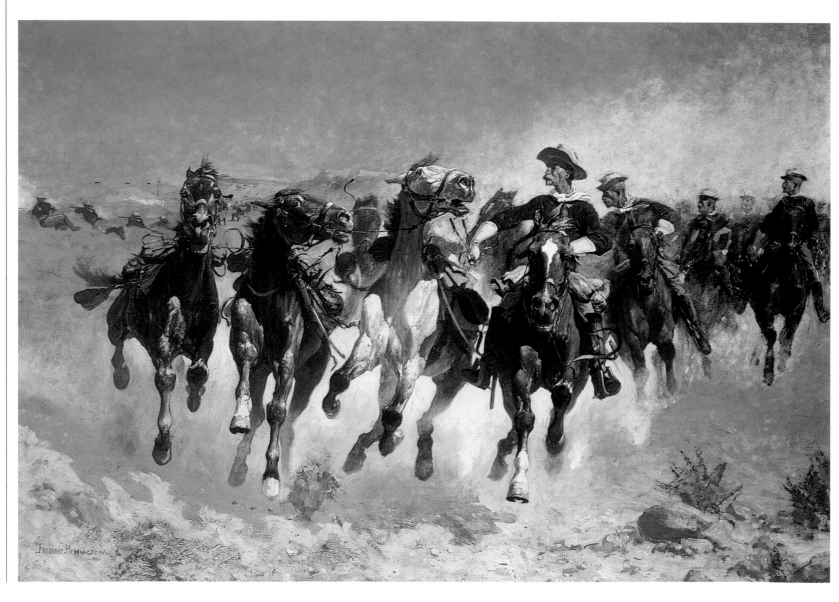

**Frederic Remington**
*The Advance Guard—*
*The Military Sacrifice*

1890
oil on canvas,
34.3 × 48.4
(87 × 123 cm)
Art Institute of Chicago

An eloquent example
of the artist's spare but
accurate style; by leaving
the background landscape
in pale tonalities, he
concentrates attention
on the figures of the
soldiers and their horses.

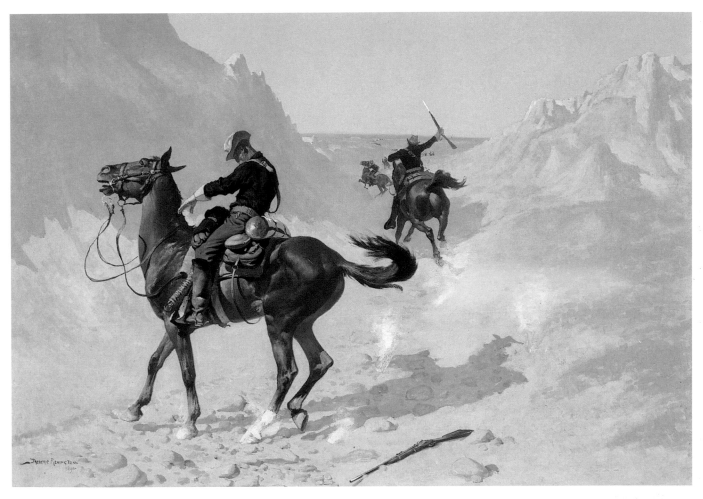

**Frederic Remington**
*Register Rock, Idaho*

1891
oil on canvas, 17 × 27.7
(43.5 × 70.5 cm)
Amon Carter Museum,
Fort Worth, Texas

"I knew the wild riders
and the vacant land were
about to vanish forever…
and the more I considered
the subject, the bigger
the forever loomed,"
the artist said. Remington
saw himself in the role of
historical recorder of the
West, making portraits
of Indians and horse
soldiers at a time when
the railroad had already
reached the Pacific.

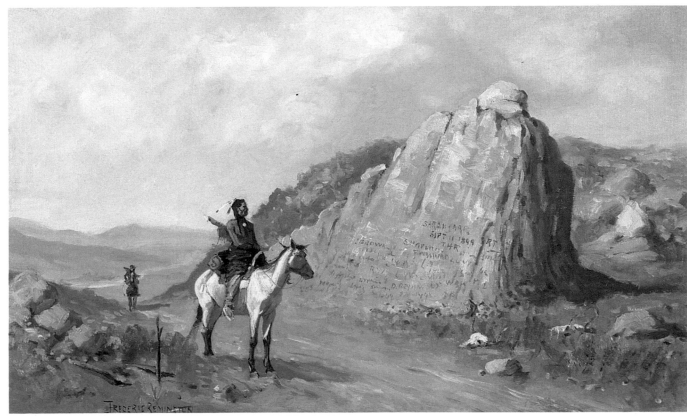

**George Inness**
*June*

1882
oil on canvas, 30.3 × 44.9
(77 × 114 cm)
Brooklyn Museum,
New York

With its radiant conquest
of atmospheric effects
and *en plein air* colors,
this work ranks among
Inness's rare, felicitous
"Impressionist" works.

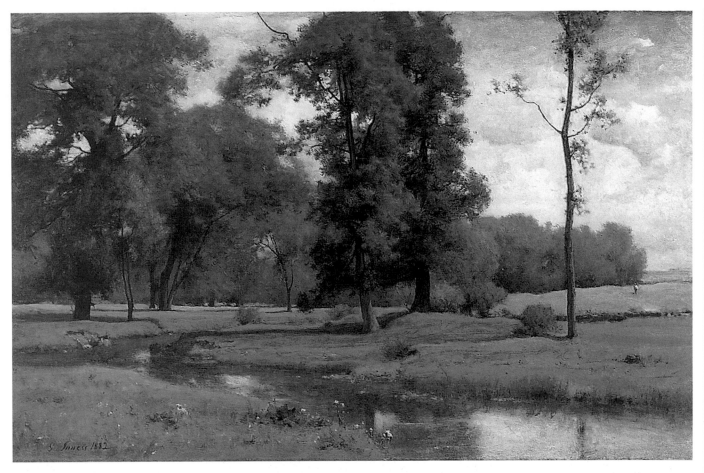

**George Inness**
*Indian Summer*

1894
oil on canvas, 30 × 45.3
(76 × 115 cm)
Collection of George M.
Curtis, Clinton, Iowa

In the later years of his
career Inness preferred
autumnal colors and hazy,
humid atmospheres.

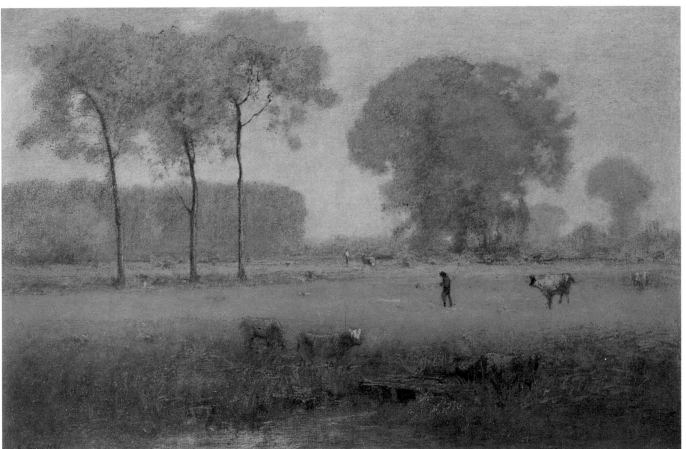

# James McNeill Whistler

*Lowell, Massachusetts, 1834–London, 1903*

Despite dandyism, involvement in literary debates, an international identity, and a vague and unresolved "Oedipus complex" with Europe, James Abbott McNeill Whistler remains an emblematic figure of American art and society at the end of the nineteenth century. He is a painter of extraordinary technical talents and of definite importance, but more for European painting (in particular English) than for the North American school, from which he always maintained his distance. After early training at home, and with the unusual sideline of time spent learning engraving as a navy cartographer, Whistler moved to Paris in 1855, immediately coming in contact with such realist painters as Gustave Courbet and Henri Fantin-Latour. In 1859 he went to London, where he spent much of his life importing and promoting an English version of Impressionism. So complete was Whistler's insertion in the artistic scene of London that in 1886 he was made president of the Society of British Artists. Thanks to him the period of the Pre-Raphaelites comes to an end, replaced by his more seductive and rarefied images of Victorian high society. It was a world of refined conventions and formalities beneath which far different emotions were held in check, but only barely. Whistler was aware of the subtle line that runs between an accurate portrait and an overly highbrow image. He made the gradual movement to sophisticated symbolism, the fruit of his careful "aesthetic" selection of subjects.

**James McNeill Whistler**
*Symphony in White No. 1
(The White Girl)*

1862
oil on canvas, 84.6 × 42.5
(215 × 108 cm)
National Gallery of Art,
Washington, D.C.

"As music is the poetry of sound, so is painting the poetry of sight." Whistler liked to give his works titles from the world of music—arrangement, harmony, or, as here, symphony—adding an indication of the dominant color tone. For this painting, exhibited at the Salon des Refusés in Paris in 1863, Whistler used his lover Joanna ("Jo") Hiffernan as model. Even before Edouard Manet, the American painter was fashioning a modern and sensual reworking of Diego Velázquez.

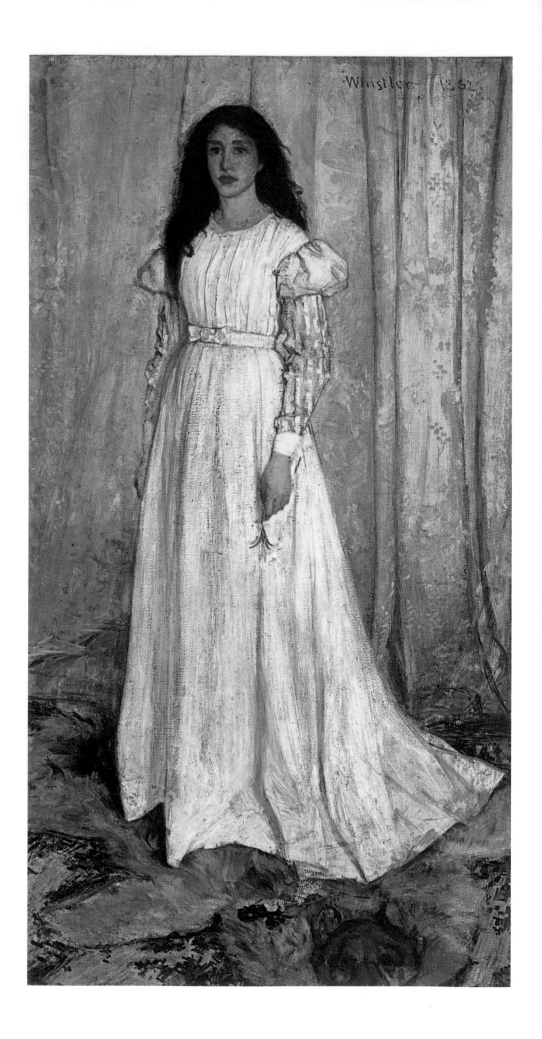

**James McNeill Whistler**
*Arrangement in Gray and
Black No. 2: Thomas Carlyle*

1872-73
oil on canvas, 67.3 × 56.5
(171 × 143.5 cm)
Art Gallery and Museum,
Glasgow

The stylized butterfly in
a circle on the lower wall
to the right, just behind
the famous author, is the
artist's symbol, which
he used as a signature or,
more exactly, as a mark,
having taken the idea from
Japanese printmakers.

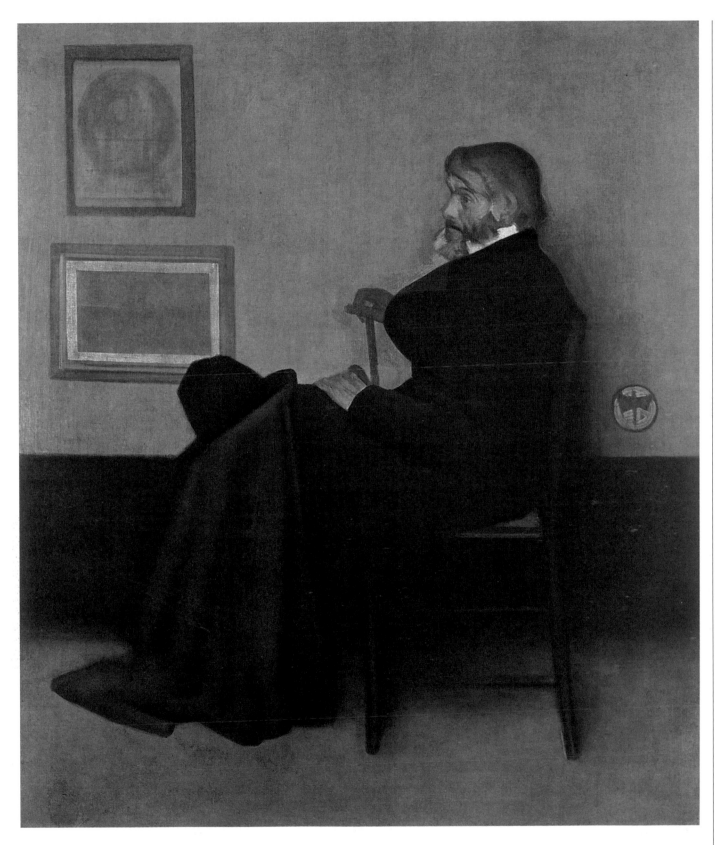

**William Merritt Chase**
*In the Atelier*

c. 1880
oil on canvas, 28.3 × 40.2
(72 × 102 cm)
Brooklyn Museum,
New York

Beyond its immediately
pleasing qualities, this
painting offers a charming
historical reconstruction
of the bric-a-brac shelf
of a successful late
nineteenth-century
painter. The objects on
display include Oriental
fabrics, prints, plants,
books, flowers, plaster
statues, knickknacks,
objects, and furnishings
of various provenance and
contrasting levels of value.

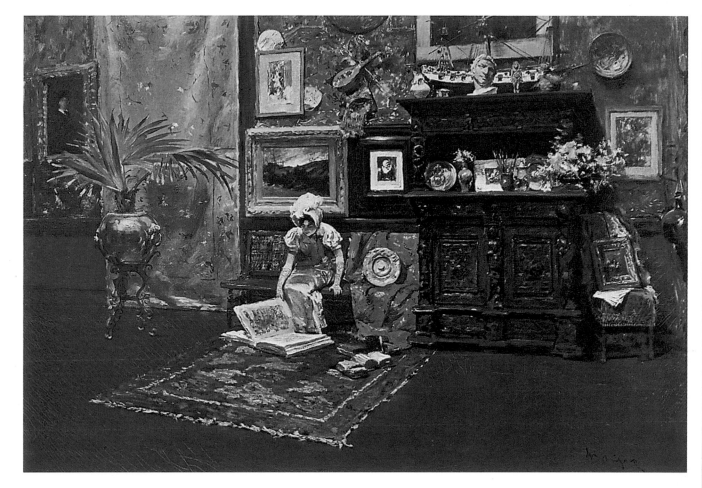

**William Merritt Chase**
*A City Park*

c. 1888
oil on canvas, 13.6 × 19.7
(34.6 × 50 cm)
Art Institute of Chicago

Chase was without doubt
one of the most versatile
of the American
Impressionists. While
Inness and Twachtman
concentrated almost
exclusively on landscapes,
Chase shifted easily from
interiors to exteriors,
striking a successful
balance between the
heightened sensibility
of the figures and the
luxurious evocation
of the settings.

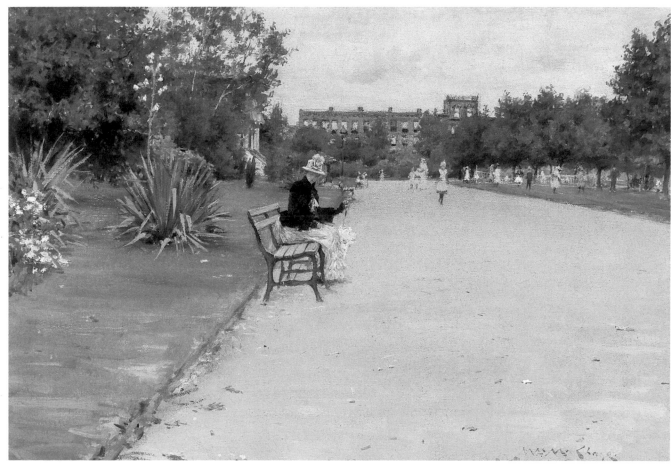

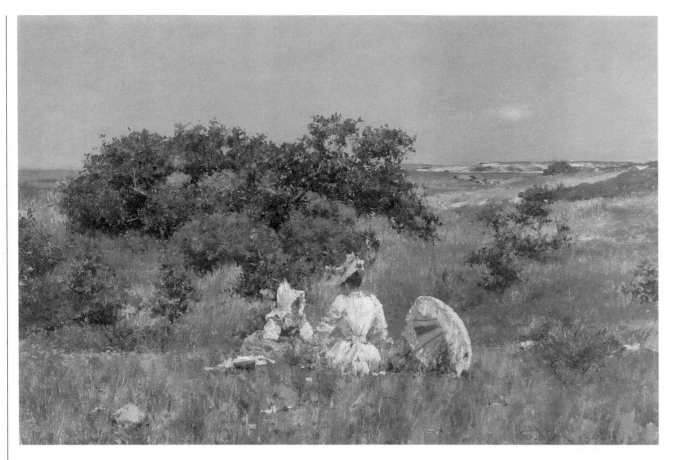

**William Merritt Chase**
*The Fairy Tale*

1892
oil on canvas, 16.5 × 24.4
(42 × 62 cm)
Private collection

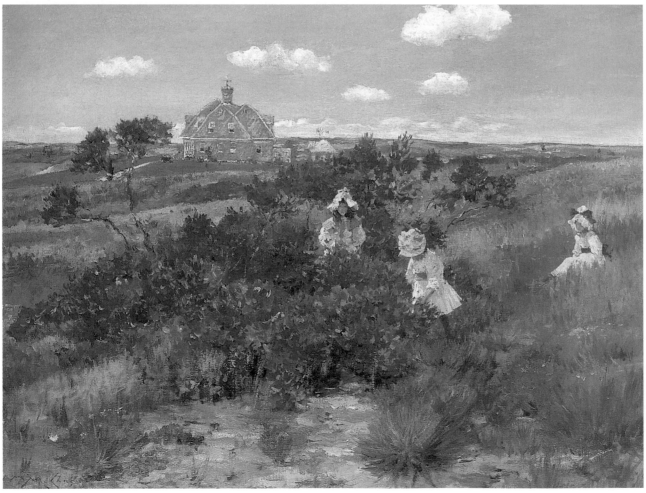

**William Merritt Chase**
*The Bayberry Bush*

c. 1895
oil on canvas, 25.6 × 33.1
(65 × 84.2 cm)
Parrish Art Museum,
Southampton, New York

Works like this call
attention to the strong ties
between William Merritt
Chase and the luminous
atmospheres of the early
Monet, ties that are highly
discernible, for example,
in the use of colored
shadows in the bushes
in the foreground. It is
interesting to recall that
Chase never visited Europe
and that his "Impressionist"
style, apparently so direct
and orthodox, was in
reality the result of
second-hand observation.

**William Merritt Chase**
*A Friendly Call*

1895
oil on canvas, 30.1 × 48.2
(76.5 × 122.5 cm)
National Gallery of Art,
Washington, D.C.

With the passing of years,
Chase moved toward
a delicate intimism,
thus distantly following
the evolution of French
painting in its passage from

"historical" Impressionism
to the postimpressionism
of Pierre Bonnard
and Edouard Vuillard.
The unchanging
characteristics of Chase's
works are the pale colors,
smooth outlines, and
descriptive richness, which
is expressed in a multitude
of narrative details.
In this work, those details
are literally doubled by
the presence of a large
mirror to the right.

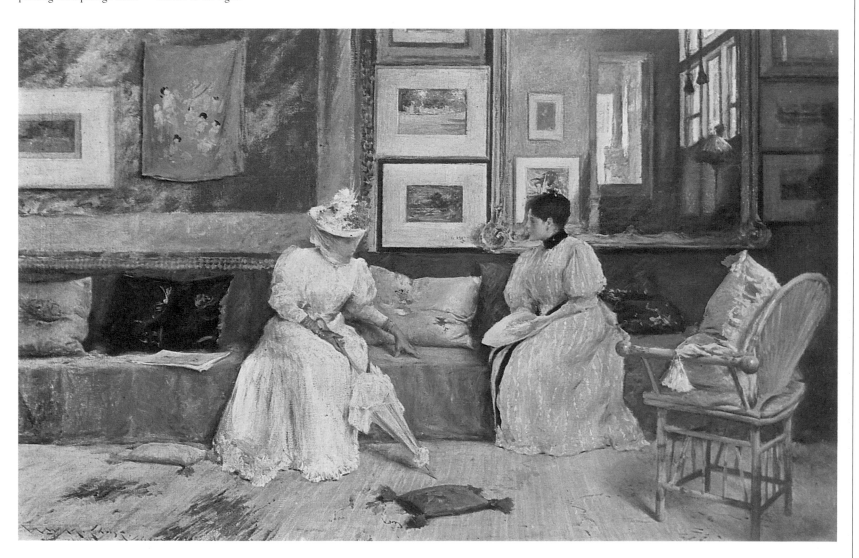

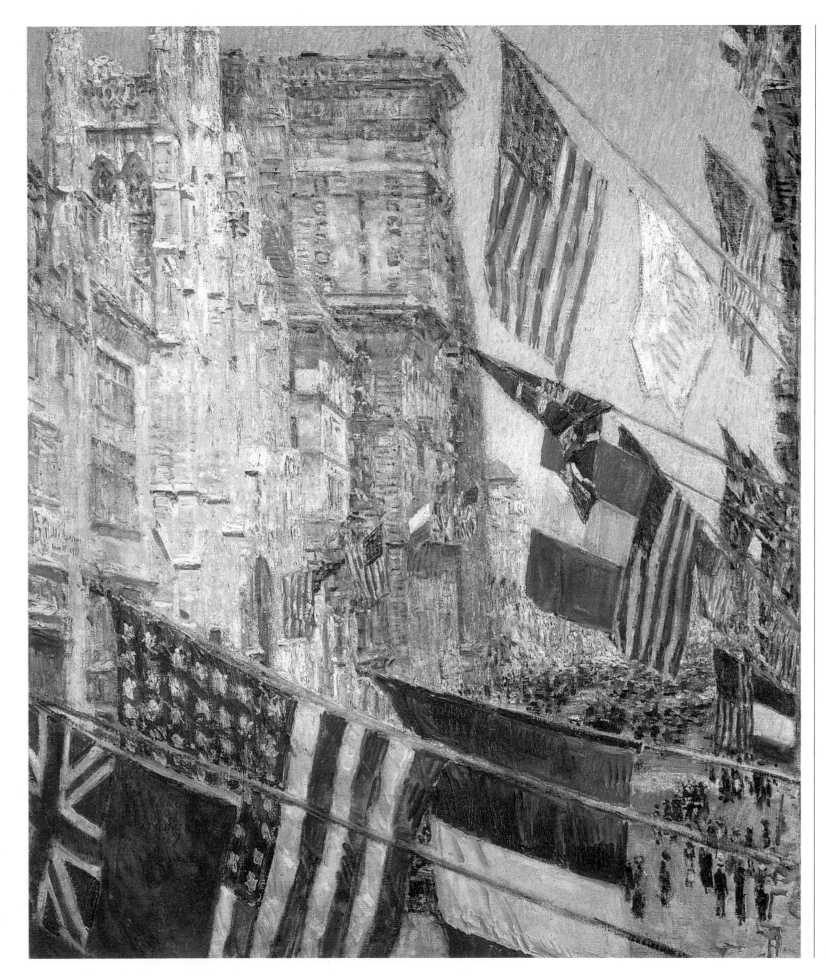

# The Eight

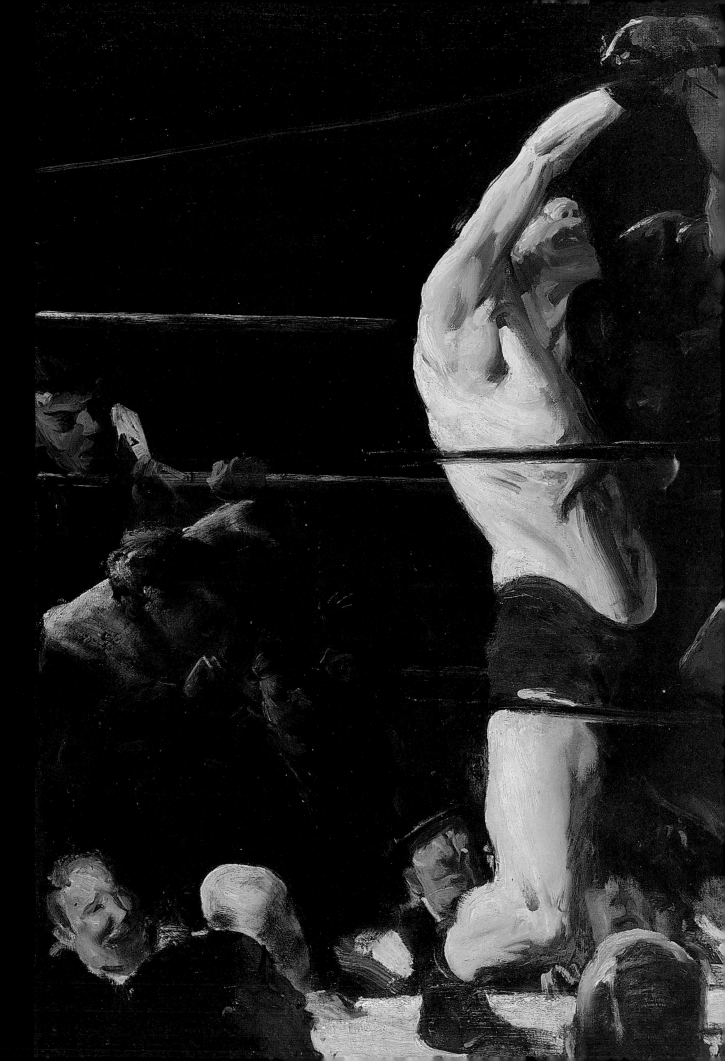

**George Bellows**
*Two Members
of the Same Club*, detail

1909
oil on canvas, 45.2 × 63.8
(115 × 160.5 cm)
National Gallery of Art,
Washington, D.C.

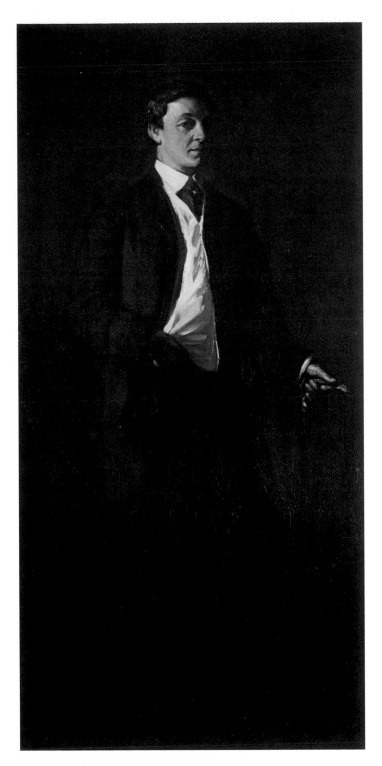

**Robert Henri**
*Portrait of William J. Glackens*

1904
oil on canvas, 78 × 38
(198 × 96.5 cm)
Nebraska Art Association,
Lincoln, Nebraska

In order to gain experience and skill in the creation of portraits, Henri spent the first years of the twentieth century making studies, drawings, and paintings of friends and relatives.

This portrait of his friend Glackens is one of the most famous works from that period. Glackens is presented full-figure in a relaxed, elegant pose, illuminated by a source of light that puts him into relief against the dark, surrounding background while also calling attention to the extension of his body and the expression on his face. The portrait was one of Henri's favorite genres, and in his portraits

one notes the influence of the paintings of Whistler and the portraits by great masters of the past: Hals, Rembrandt, Velázquez, models to whom Henri made reference over the course of his career as a painter. The study of the works of those artists furnished Henri with a vast array of pictorial and compositional ideas with which to enrich his stylistic and expressive vocabulary.

**Robert Henri**
*Salome*

1909
oil on canvas, 77.5 × 37
(196.9 × 94 cm)
State Art Museum
of Florida, Sarasota

Presented full-figure in her stage costume, this dancer testifies to Henri's fondness for the world of dance and also to his admiration for Edgar Degas. Henri encountered Impressionist painting during his long stay in Paris, and it had a notable effect on his pictorial language. Here he takes no time to dwell on details and instead gives the subject a lively and immediate presence.

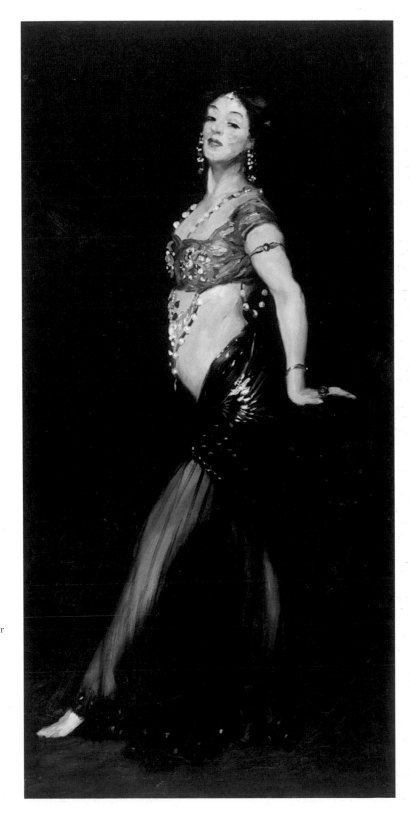

**Robert Henri**
*The Ice Floe*

1902
oil on canvas, 25.6 × 31.7
(65.1 × 81 cm)
Fine Arts Museums
of San Francisco

The painting, with its
primarily blue tones
enlivened by small touches
of red, presents a freezing
cold winter day. Ships
make their way along the
river, pushing through ice
and leaving trails of smoke
in their wake that rise into
the cold air. Henri moved
to New York in the fall of
1900, and the paintings he
made during the first years
of the new century had
a great deal of influence
on the works of the young
artists who visited his
studio and later joined
with him in the Eight.

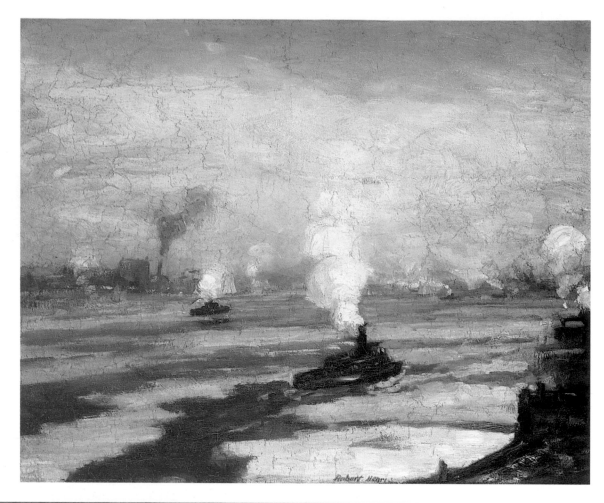

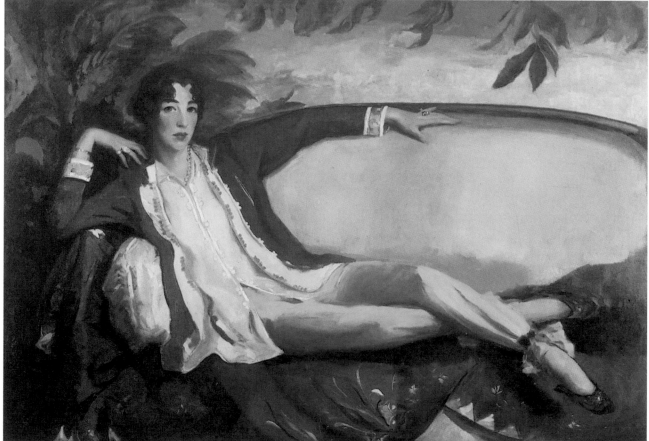

**Robert Henri**
*Gertrude Vanderbilt Whitney*

1916
oil on canvas, 50 × 72
(127 × 182.9 cm)
Whitney Museum of
American Art, New York

The elegant woman
presented here was
among the leaders of
the sophisticated art
world of New York at the
beginning of the century.
Gertrude Vanderbilt
Whitney, an artist herself,
was a farsighted patron
and collector of American art.
At the famous 1908 show
at the Macbeth Gallery
in which the Eight
exhibited, she bought
four paintings for her
collection, for a total
of $2,200. In 1914 she
opened the Whitney
Studio in New York;
in 1928 it became the
Whitney Studio Galleries,
the original nucleus of
the Whitney Museum
of American Art, one
of the most famous
museums of American
art, which opened its
doors in 1931.

**Robert Henri**
*Snow in New York*

1902
oil on canvas, 32 × 25.7
(81.2 × 65.3 cm)
National Gallery of Art,
Washington, D.C.

Henri painted numerous
canvases of New York
under a blanket of snow.
A street runs down the
center of this painting,
the tall buildings to its
sides acting much like
theater curtains for the
scene. A few carriages
move along, a few
passersby make their way
down the snow-covered
sidewalks. The contrast
between the diffused
luminosity of the sky and
the somber darkness of
the buildings is expressed
through the use of a
limited number of colors,
primarily white, ochre,
and several shades of
brown. As he does in many
of his paintings, Henri uses
small touches of red to
brighten the chromatic
monotony of the painting.
Thus an angle of the city
that would hardly seem
picturesque becomes
the subject of artistic
reflection on the part of
Henri, who enthusiastically
expresses the poetic
essence of this urban scene
with an immediacy and
naturalness that recall
the works of the
Impressionists.

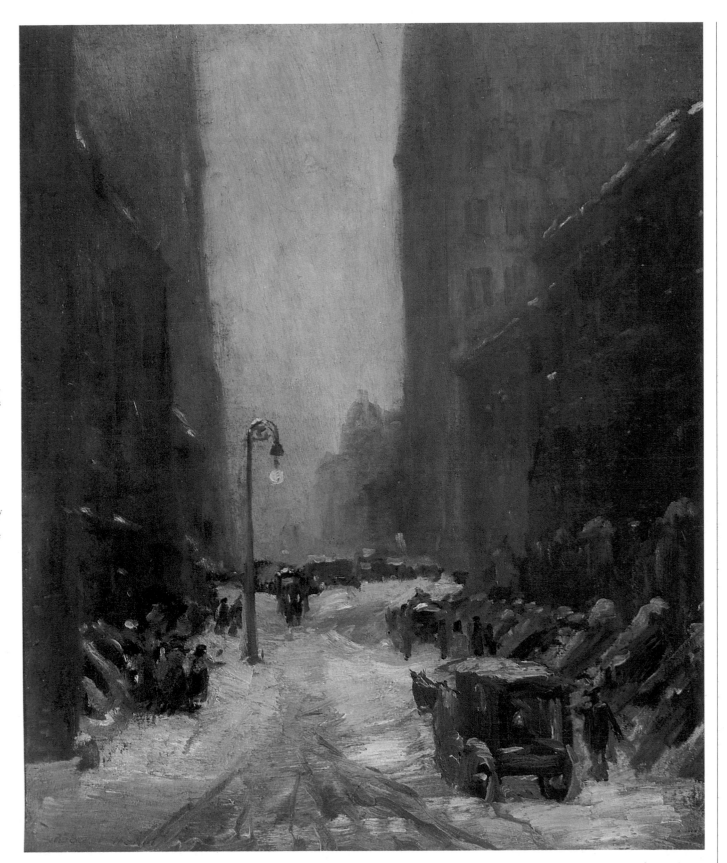

**Ernest Lawson**
*Winter on the River*

1907
oil on canvas, 33.1 × 40.2
(84 × 102 cm)
Whitney Museum of
American Art, New York

No great changes took
place in Lawson's
expressive language
between the works of his
debut and those of his
maturity; up to the very
end of his career he was
fascinated by the romantic,
hushed atmospheres of
the rural and riverside
landscapes just outside
New York City, which
he presented with light,
carefully juxtaposed
brushstrokes, in delicate
colors that create
a diffused and
vibrant luminosity.

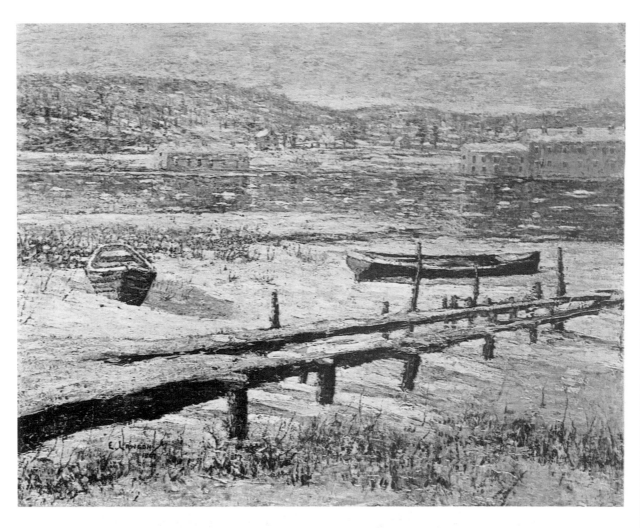

**Ernest Lawson**
*Hills at Inwood*

1914
oil on canvas, 36 × 50
(91.4 × 127 cm)
Columbus Gallery of Fine
Arts, Columbus, Ohio

Lawson was the only
one of the artists of
the Eight dedicated
to landscape painting.
In this image, he creates
a perfect synthesis of form
and color. Lawson was not
interested in merely the
play of light; he had seen
works by Cézanne at the
1913 Armory Show, and
like that French painter
he was working toward
a more structured and
solid vision.

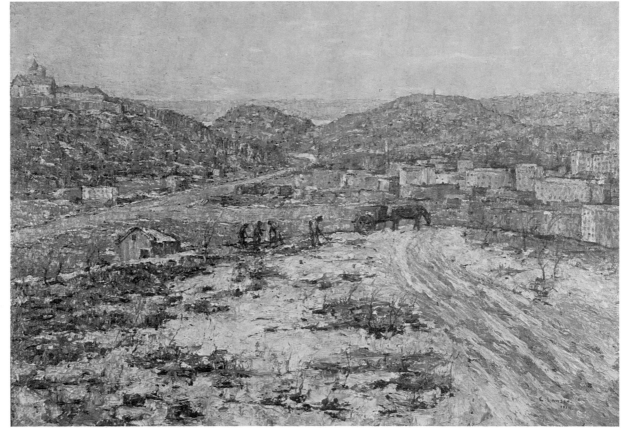

## Maurice Prendergast

*St. John's, Newfoundland, 1859–*
*New York, 1924*

Fascinated by Impressionist and
Postimpressionist painting, Maurice
Brazil Prendergast, one of the Eight,
shuttled between Europe and
New York many times. He visited
England in 1886 and lived in Paris
for three years (1891–94), studying
painting at the Académie Julian.
While in Paris he studied the works
of Gauguin and the Nabis painters
Pierre Bonnard and Edouard Vuillard,
all of whom exercised a strong
influence on his expressive language.
His first personal show was at Boston's
Chase Gallery, in 1897. The next year
he was again in Europe, spending time
in Paris and Venice. Of all the many
American artists influenced by
Impressionism and Postimpressionism,
Prendergast represents the most
original response: The vivacious
and chromatically luminous style

that he developed involves
a technique of fitting together
juxtaposed brushstrokes to create
surfaces similar to mosaics or
tapestries. In 1904 he participated
in the show at the National Arts Club
in New York and began to dedicate
himself to etching. He took part in
the 1908 show of the Eight at the
Macbeth Gallery in New York.
Between 1909 and 1912 he traveled
to Europe, and upon his return
in 1913 exhibited at the Armory
Show. An exhibition of his oils and
watercolors held at the Carroll
Gallery in New York in 1915 was
a large public and critical success,
attracting many collectors.
During the last decade of his life
he spent every summer in New
England, painting landscapes.

**Maurice Prendergast**
*The Promenade*

c. 1912–13
oil on canvas, 28 × 40.3
(71.1 × 102.3 cm)
Columbus Museum of Art,
Columbus, Ohio

The works of Maurice
Prendergast seem
completely isolated
within the sphere of
American painting at the
beginning of the century.
His original pictorial
method, composed of tiny
areas of paint applied to
the canvas like the tiles
of a mosaic, and the
resulting decorative, two-
dimensional effect give his
paintings a sense of the
works of Georges Seurat,
Paul Signac, and the Nabis
painters, especially Vuillard
and Bonnard, whom he
had occasion to see during

his many visits to Paris.
Prendergast seems more
interested in the overall
effect of a painting than
in the formal definition
of each separate element.
Everything in this painting
seems to be in the
foreground. The people
out for a Sunday stroll
along the shoreline, all of
them figures without faces,
are delineated with only
a few brushstrokes;
the background is
composed of the blues
of the ocean and the sky.
Prendergast painted
many versions of this same
subject, directly influenced
by Seurat's *A Sunday
Afternoon on the Island
of La Grande Jatte*.

**Maurice Prendergast**
*Ponte della Paglia*

1899
oil on canvas, 28 × 23
(71 × 58.5 cm)
Phillips Collection,
Washington, D.C.

This lively, immediate
image testifies to the
great impact Italy and
Venetian painting had on
Prendergast. Once again
the painting is animated
and natural, characterized
by a sense of movement
and intense, bright colors.
Prendergast's brush moves
freely, applying panes
of pure color.

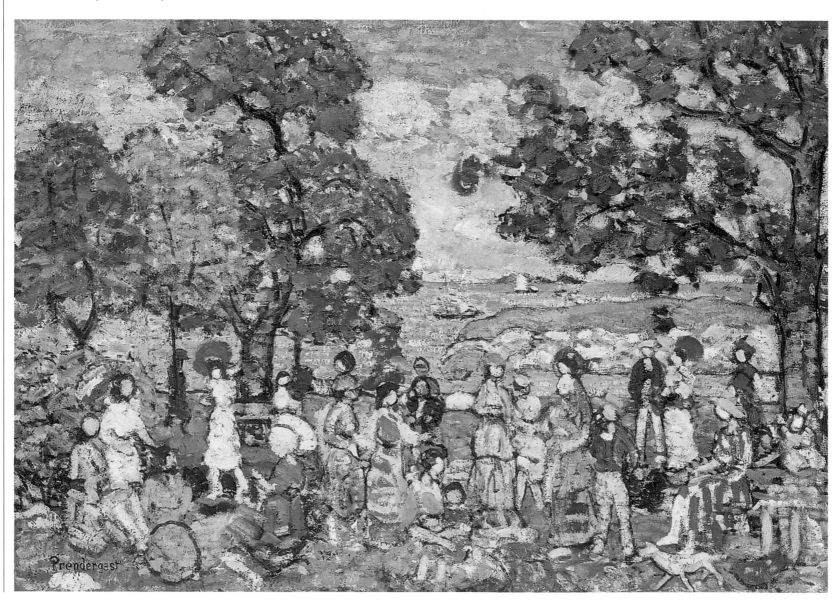

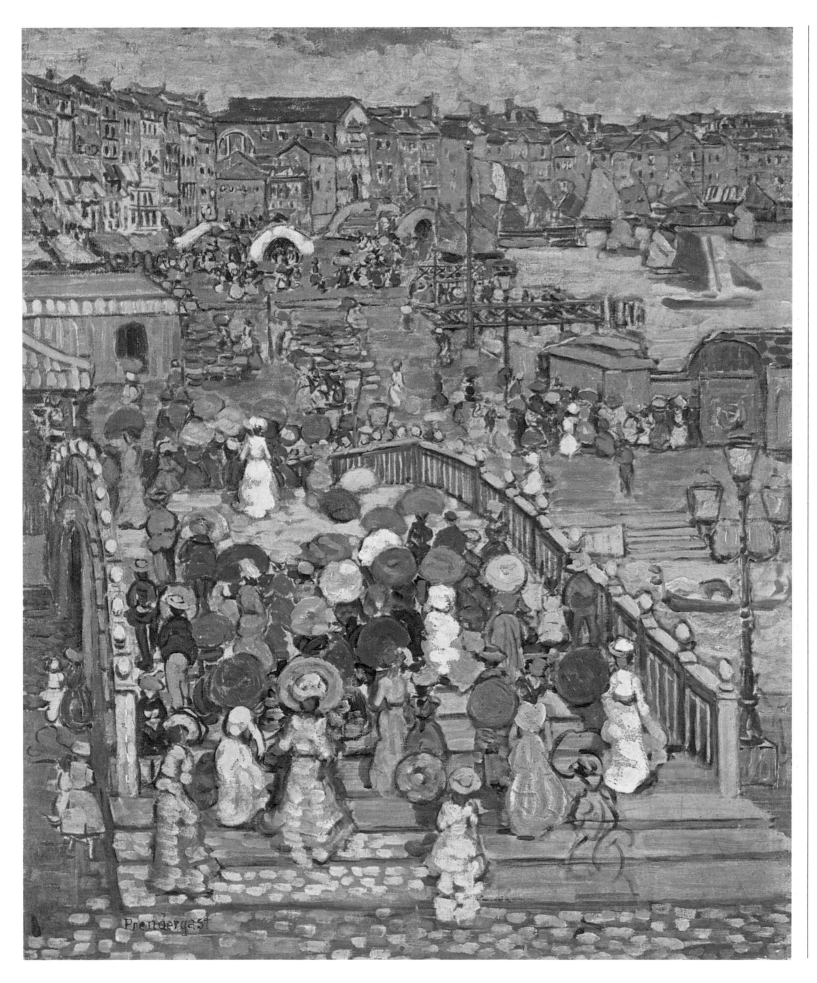

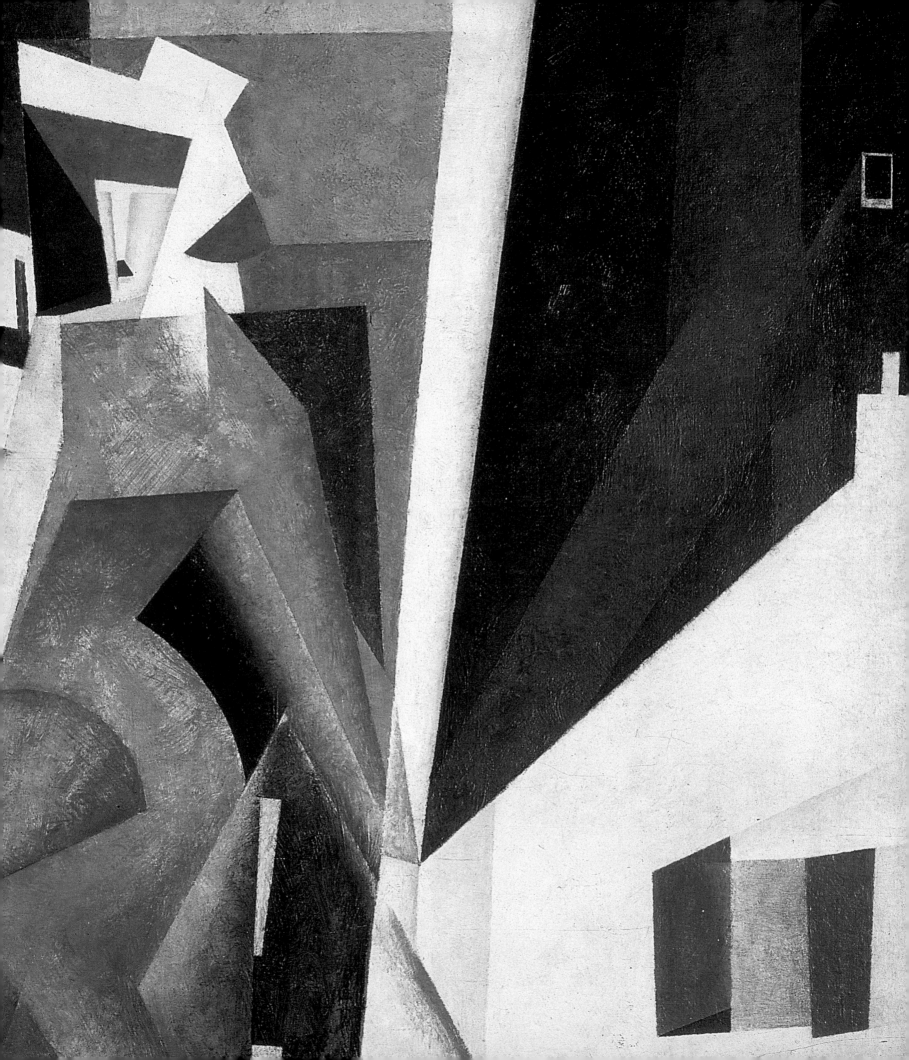

American painting experienced a radical challenge early in the twentieth century when a group of young artists gathered around the figure of Robert Henri, spokesperson for the general dissatisfaction spreading through the world of American art, rebelled against the cultured taste imposed by the National Academy of Design—an extremely conservative institution—and introduced a new expressive vitality to American painting. These young artists demanded that painting be made valid by changing its subject matter, leaving behind the old-fashioned academic subjects to represent instead scenes of contemporary reality. A dramatic change; and yet from the stylistic point of view these artists remained firmly anchored to the painting of the preceding generation.

**Charles Sheeler**
*River Rouge Plant*

1932
oil on canvas, 20.1 × 24
(51 × 61 cm)
Whitney Museum of
American Art, New York

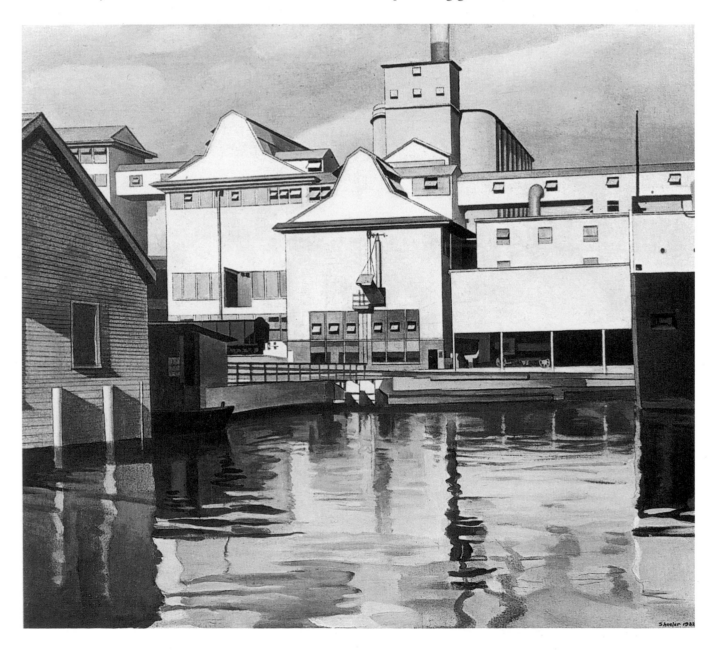

During this same period, American artists in Europe were coming into contact with new artistic currents that challenged not merely the subject matter of art, but also its form. They were influenced most of all by the painting of Paul Cézanne and Henri Matisse. In the United States, a primary means of spreading awareness of these new European movements was Alfred Stieglitz's gallery of contemporary photography and painting, three small rooms at 291 Fifth Avenue, for which reason the gallery, active from 1905 to 1917, was nicknamed the "291 Gallery," or just "291." Along with works by young American artists like Marsden Hartley, Georgia O'Keeffe, Charles Demuth, and Arthur Dove, Stieglitz exhibited works by European modernists that had not yet been displayed elsewhere in America, artists like Pablo Picasso, Matisse, Georges Braque, and Cézanne. Thus Stieglitz created a bridge between Paris and New York.

In contrast with the broad net cast by Robert Henri, Stieglitz nurtured and encouraged a small, restricted group of artists. Such artists gravitated to his gallery, where he propounded an elite art made for a culturally prepared public. Heedless of popular taste and market demands, Stieglitz pushed ahead with courageous experiments, often achieving radically innovative outcomes, and all the while laying the foundation for the birth of an authentically American art. For these reasons he is considered a decisive figure in making a skeptical American public open to the values of modern movements.

Even so, not until the 1913 Armory Show did the revolutionary currents of Europe become well known to a large number of Americans. The show, which traveled to Chicago and Boston after its time in the New York armory, offered a complete panorama of the history of modern painting, the works on exhibit ranging from Ingres to contemporary artists and including a broad selection of American paintings, both traditional and modern. The reaction of the public was violent, but from then on the tradi-

**Georgia O'Keeffe**
*Summer Days*

1936
oil on canvas, 36 × 30
(91.4 × 76.2 cm)
Whitney Museum of
American Art, New York

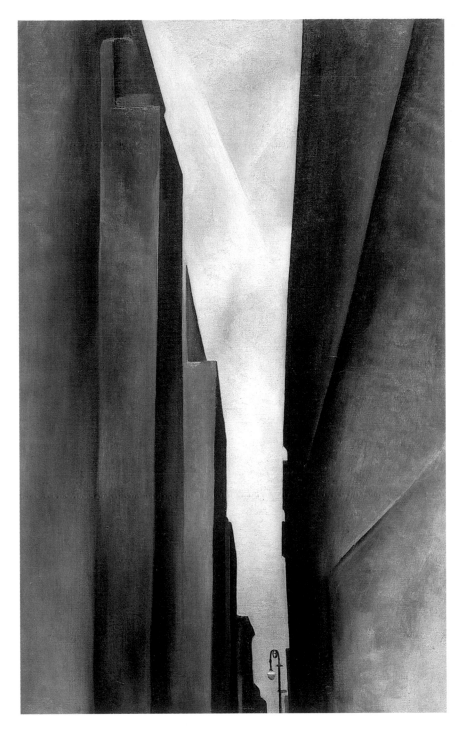

**Georgia O'Keeffe**
*Street, New York, I*

1926
oil on canvas, 48 × 30
(122 × 76 cm)
Private collection

The compression of space
that emphasizes every
plane of the image and
the extreme close-up
focus give a sense of
ironic monumentality
to ordinary objects,
leading to an exaltation
of the American landscape.

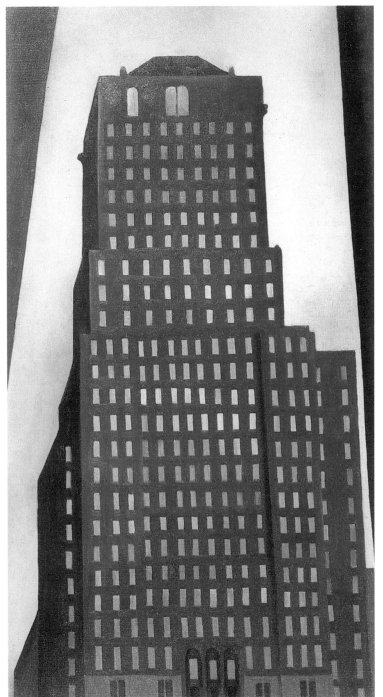

**Georgia O'Keeffe**
*Hotel Shelton, New York, I*

1926
oil on canvas, 32.1 × 17
(81.5 × 43 cm)
Regis Corporation,
Minneapolis

Following her debut
as an abstract painter,
O'Keeffe dedicated herself
to landscapes and views
of New York, introducing
a profoundly female
sensibility to precisionism.

183

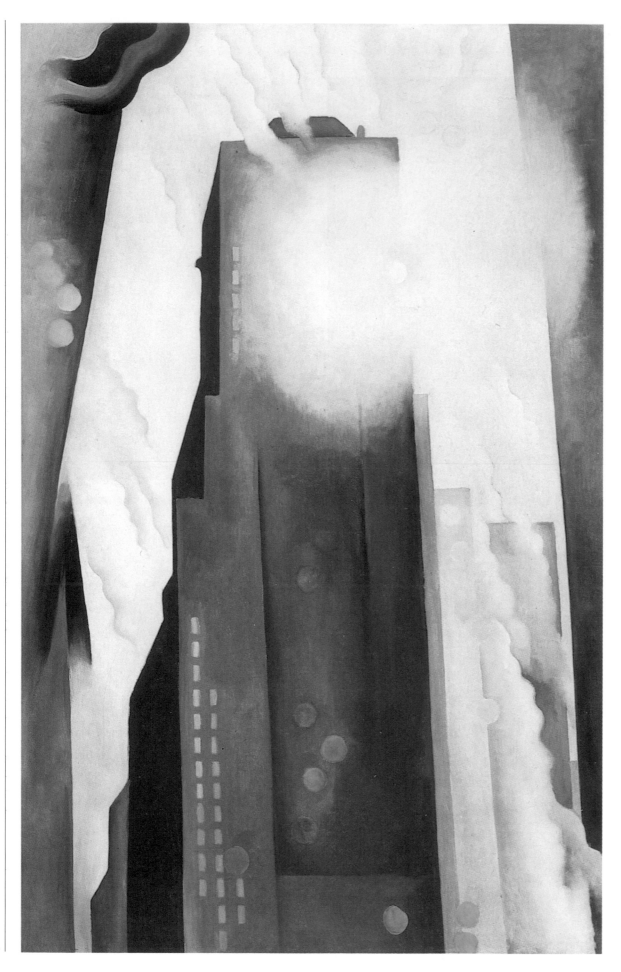

**Georgia O'Keeffe**
*The Shelton with Sunspots*

1926
oil on canvas, 48.5 × 30.2
(123.2 × 76.8 cm)
Art Institute of Chicago

Between 1925 and 1929,
while living in New York
with Stieglitz, O'Keeffe
painted unreal, dreamy
streets and skyscrapers
obscured by the sun
and the moon and thus
romantically transfigured.

**Georgia O'Keeffe**
*Two Calla Lilies on Pink*

1928
oil on canvas, 40 × 30
(101.6 × 76.2 cm)
Philadelphia Museum
of Art, Philadelphia

Rejecting all types of
realism related to the
European tradition of art,
O'Keeffe took an object
from nature, most often
a flower, concentrated
on a single detail, enlarged
it, then located it on a flat
canvas, simplified and
rendered in transparent,
antinaturalistic colors.
In this close-up vision
of two calla lilies, the
intensity of the colors
and the precision of the
line concur to make an
ordinary object sublime.

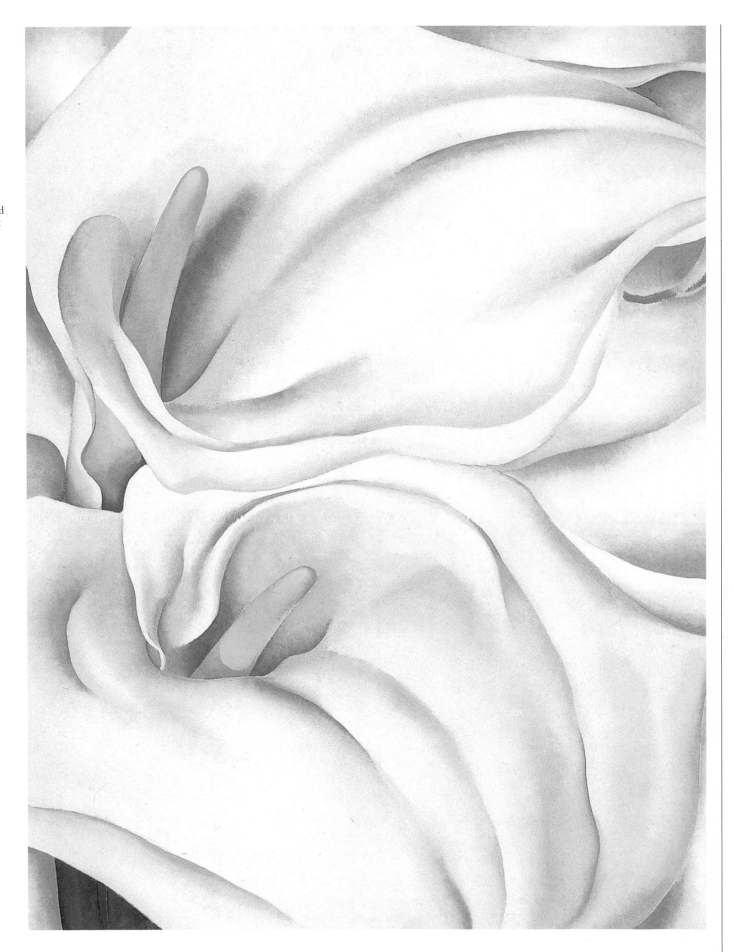

**Lyonel Feininger**
*Gables I, Lüneburg*

1925
oil on canvas, 37.8 × 28.5
(96 × 72.4 cm)
Smith College Museum
of Art, Northampton,
Massachusetts

Feininger here applies
Cubist fragmentation
to an urban landscape,
arranging open and
closed spaces to form
a harmonious abstract
combination. Exploiting
the geometry of doors,
windows, stairs, and roofs,
he transforms the historic
buildings of a provincial
city near Hamburg into
abstract geometric forms.

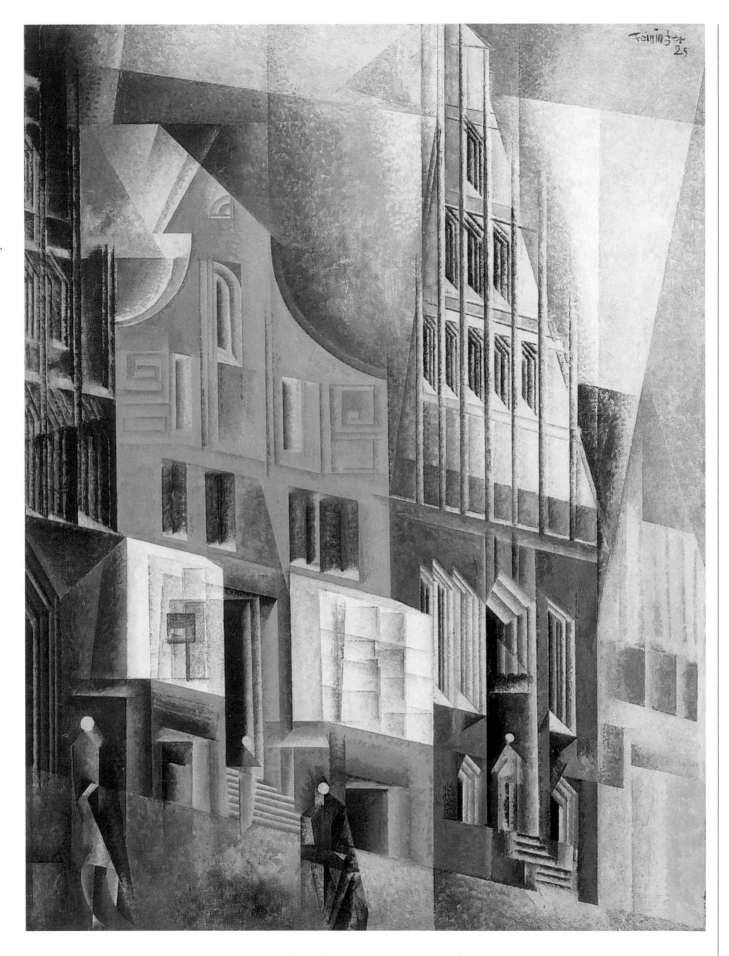

# Man Ray

*Philadelphia, 1890–Paris, 1976*

Painter, photographer, and filmmaker, Man Ray was above all an artist convinced of the absolute superiority of the image and its meaning to the means used to achieve them; he also saw an absolute equality among the various means of artistic expression. Together with Picabia and Duchamp, whom he met in New York in 1915, he founded the American Dada movement. In 1921 he moved to Paris, where Duchamp introduced him to the French Dadaists, who involved him their activities. With his so-called ready-mades, Duchamp transformed ordinary objects into works of art—the mere fact of being deemed works of art by

an artist gives them that status; Man Ray acted to modify the object, separating it from its natural context. Among Man Ray's most famous works are *Gift* (1921), an iron to which he attached a row of nails, and *Object to Be Destroyed* (1923), a metronome with the "eye" of the loved-hated woman attached to the pendulum. He took his iconoclastic openness to accidents and chance results into experiments in the field of photography. Doing without a camera and working instead directly on photographic film, he obtained abstract black-and-white images. These rayographs, as they came to be called, are photographs made by the direct application of objects of varying opacity to a light-sensitive plate. He published a collection of twelve rayographs in 1922, under the title

*Les Champs Délicieux*, with an introduction by Tristan Tzara. Man Ray showed similar inventiveness when he entered the world of the motion picture; irrationality, automatism, absence of plot, psychological and dreamlike sequences apparently without logic are features of his films. In 1926, working in collaboration with Duchamp, he made the short film *Anémic Cinéma*. During the 1930s he returned to the construction of enigmatic objects, often repeating them many times, considering their construction more important than the idea of them. In the United States between 1940 and 1951, he later returned to Paris, where he died in 1976.

**Man Ray**
*Le Beau Temps*

1939
oil on canvas,
Private collection

With this work, on the eve of World War II, Man Ray took leave of the city of Paris to return to the United States. Using iconography at the outer limits of figurative art, he assembled several unsettling elements. To the left, an androgynous mannequin has for a head a lantern illuminated by a candle. It is flanked by two gigantic forks; behind it is a shattered wall beneath a black sky. To the right, behind the yellow-glass wall of a building, a couple can be seen embracing; their embrace is contrasted with a battle between a pair of beasts taking place on the roof. The painting remained in the possession of Man Ray's wife, Juliet, until it was sold at Sotheby's in London in 1994.

**Man Ray**
*The Rope Dancer Accompanies
Herself with Her Shadows*

1916
oil on canvas, 52 × 73.4
(132 × 186.4 cm)
Museum of Modern Art,
New York

Beginning in 1915,
Man Ray emphasized
the two-dimensional
aspect of the painted
surface, dismembering
compositions into flat
forms with clearly
delineated outlines.
Such is the case with
this painting, in which
the shadow shapes created
by the movement of a rope
dancer are dynamically
aligned across the
surface of the canvas.

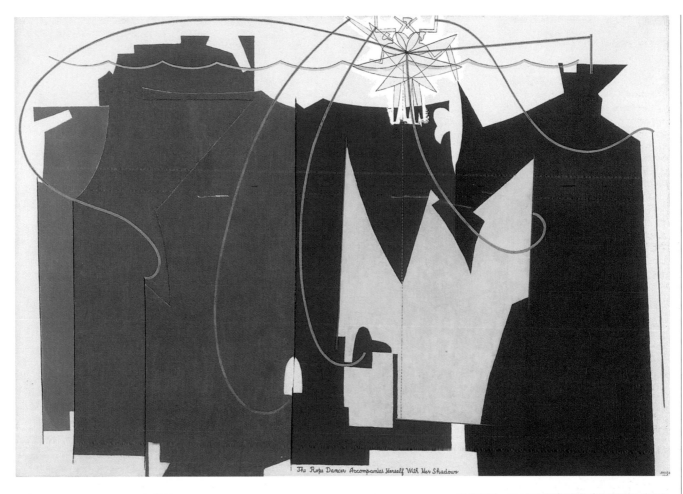

**Man Ray**
*Symphony Orchestra*

1916
oil on canvas, 52 × 36
(132 × 91.5 cm)
Albright-Knox Art Gallery,
Buffalo, New York

**Man Ray**
*L'Homme Infini
(The Infinite Man)*

1942
oil on canvas, 70.9 × 49.4
(180 × 125.5 cm)
Giorgio Marconi
Collection, Milan

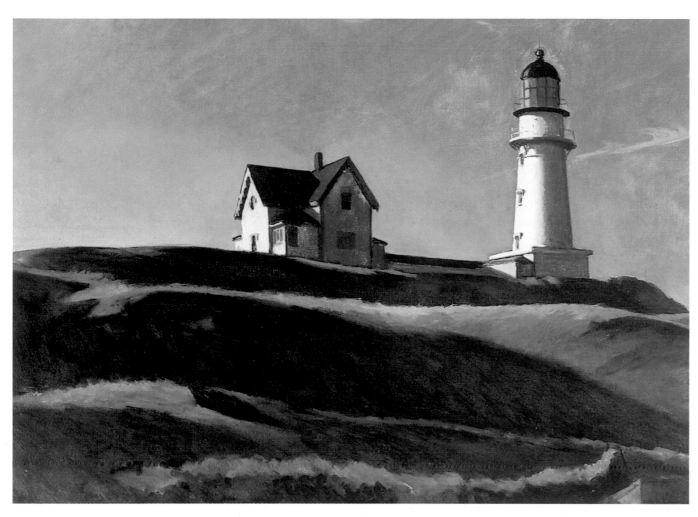

**Edward Hopper**
*Lighthouse Hill*

1927
oil on canvas, 28.3 × 39.5
(71.8 × 100.3 cm)
Dallas Museum of Art,
Dallas, Texas

In many Hopper paintings
an element that recalls
human civilization is set
down in the middle of
nature, a clear reference
to the concept of the
"frontier" as a place on
the edge of the civilized
world where human beings
encounter nature.
The house and lighthouse
are symbols of civilization,
signs of the presence of
man. Hopper uses a play
of light and shadows to
throw into relief the
façade of the house,
the cylindrical volume
of the lighthouse, and
the slopes of the hills
that limit of the spectator's
field of vision and cut off
all view of the sea.

**Edward Hopper**
*Sunday*

1926
oil on canvas, 29 × 34
(73.6 × 86.3 cm)
Phillips Collection,
Washington, D.C.

Hopper transforms
moments from everyday
life into universal, timeless
themes; he makes small,
isolated events take place
against a history without
heroes. The isolation of this
man seated on the edge of
sidewalk is so complete
that he does not seem even
minimally related to his
surroundings. The city
seems dead, not a single
other living soul is visible,
the store windows
are empty. The intense
illumination serves only
to heighten the sense
of silence that emanates
from the painting.

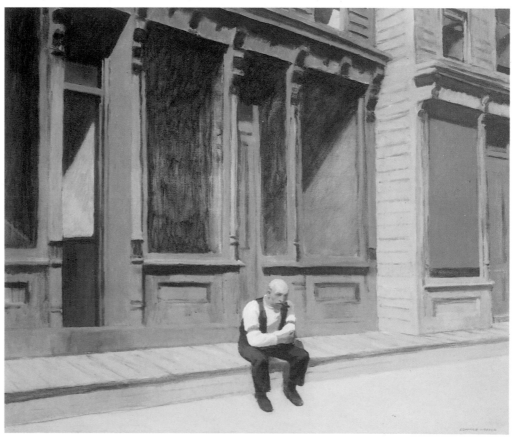

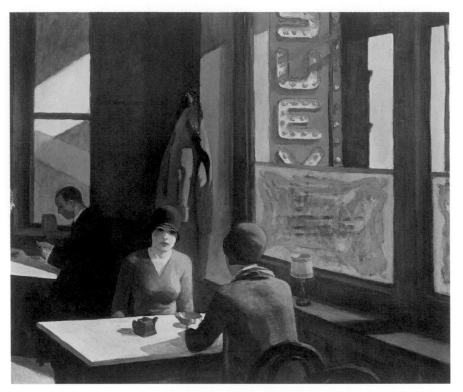

**Edward Hopper**
*Chop Suey*

1929
oil on canvas, 32 × 38
(81.3 × 96.5 cm)
Collection of Mr. and Mrs.
Barney A. Ebsworth

This is an ambivalent image, balanced between the sensuality of the woman at the center of the painting and the solitude that surrounds and isolates all the figures in the image. They are unable to communicate or to interact, not even with the people seated across from them. The woman who looks toward the viewer wears highly visible makeup, her red lips standing out against her pale skin, and she seems so rigid one almost thinks of an inanimate mannequin, making her much like the other clients in the restaurant.

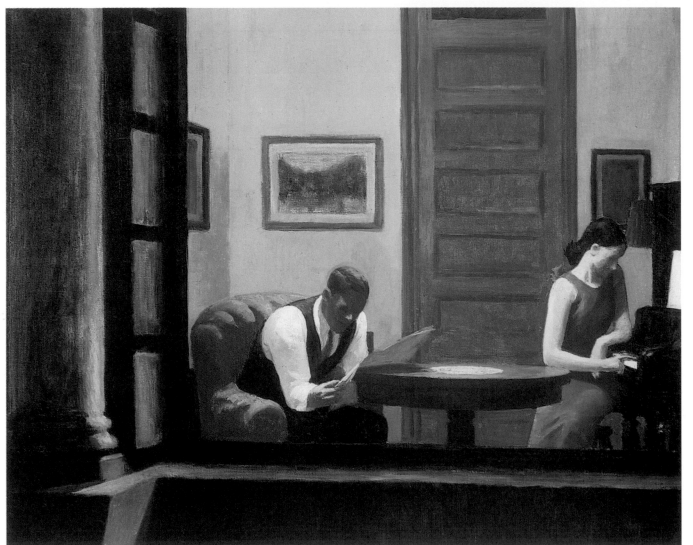

**Edward Hopper**
*Room in New York*

1932
oil on canvas, 28.9 × 36
(73.5 × 91.5 cm)
Sheldon Memorial Art
Gallery, University
of Nebraska, Lincoln

The window is an element that often appears in Hopper paintings, serving to divide the viewer from those who are viewed, the interior from the exterior. The window becomes a screen on which feelings and emotions are projected. The visual angle chosen by the artist is reminiscent of a movie angle and offers a view into a room in a building much like any other. A couple can be seen amid middle-class furniture. Each is enclosed in his or her individual reality, the man reading the newspaper, the woman, lost in her own thoughts, tapping out a few notes on the piano. There is no relationship between the two figures, and the silence of their isolation is emphasized by their faces, which are barely indicated, summarily modeled by the artificial light that comes from above.

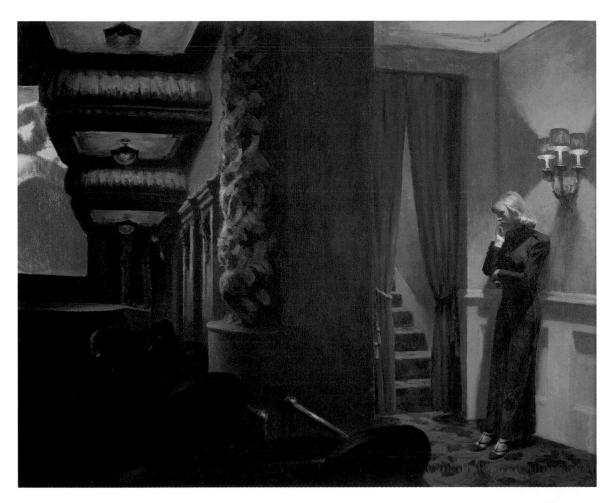

**Edward Hopper**
*New York Movie*

1939
oil on canvas, 32.2 × 40.1
(81.9 × 101.9 cm)
Museum of Modern Art,
New York

Among the symbols of
contemporary civilization,
the movie theater is one
of the most fascinating.
But the film being watched
by a few spectators seated
in the half light before the
screen holds no interest
for the young female usher
standing to the right; she
has seen it too many times
and, anyway, is absorbed
in her own thoughts.
Light plays a particularly
important role in this
painting, as in all Hopper
paintings, becoming
an active element of
the composition. Hopper
uses it to call certain
details into evidence,
to confer greater veracity
on the overall image,
to give greater life to
the colors, such as the
red that dominates
the entire painting.

**Edward Hopper**
*Summertime*

1943
oil on canvas, 29.1 × 44
(74 × 111.8 cm)
Delaware Art Museum,
Wilmington, Delaware

The fulcrum of this
painting is the young
woman at its center,
illuminated by clear
morning light. A slight
breeze moves her dress
and the window curtains
in the apartment.
The sharp geometries
of the architecture contrast
with the sensual presence
of the woman in this image
with a dreamlike essence.

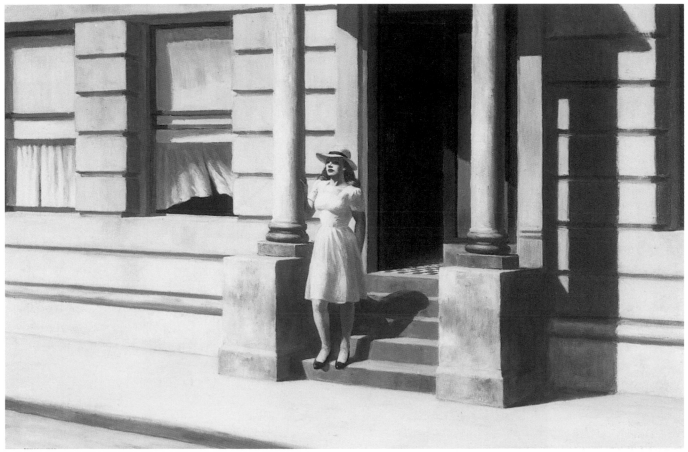

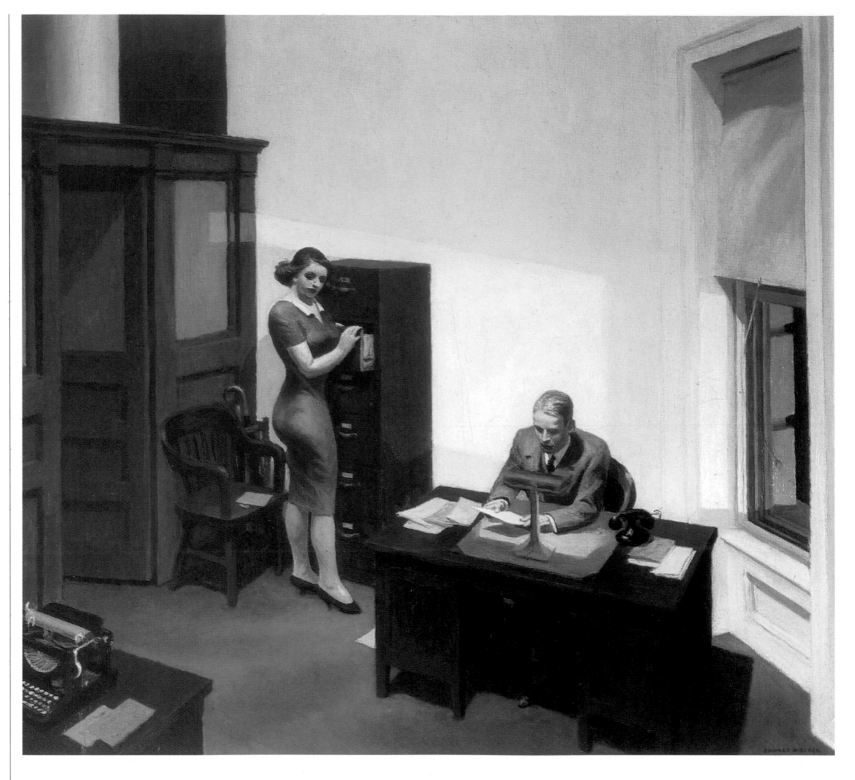

**Edward Hopper**
*Office at Night*

1940
oil on canvas, 22.1 × 25
(56.2 × 63.5 cm)
Walker Art Center,
Minneapolis

Work is another aspect
of urban reality that
Hopper explores, in this
case presenting a brightly
lit, starkly furnished office:

a table in the foreground
with a typewriter, a man
seated at a desk reading;
beside him a woman at
a filing cabinet. Once
again, a man and a woman
are alone at night in a
small interior, but they
seem immobile, suspended
in time, isolated in their
thoughts, unable to
communicate. The pale
light that fills the room,
coming from both inside

and out, calls attention
to the distance that
separates them, making
the individuals stand out
more sharply and giving
voice to a profound sense
of alienation and solitude.

**Grant Wood**
*Dinner for Threshers*

1934
oil on masonite,
19.5 × 79.5
(49.5 × 201.9 cm)
Fine Arts Museums
of San Francisco

The unusual format of
this work allows Wood to
create an image of both the
exterior of a farmhouse
and, in cross-section, its
interior. The threshers are
coming in from the fields
for dinner; the women of
the farm prepare and
serve the meal. Threshers
arriving late wash up or
comb their hair; others are
already seated at the long
table. On the back wall,
a picture of horses adds a
touch of life to the simple
rural interior; the kitchen
is spartan but functional.
This nostalgic view of life
in a rural community of
Iowa is not without
touches of humor.

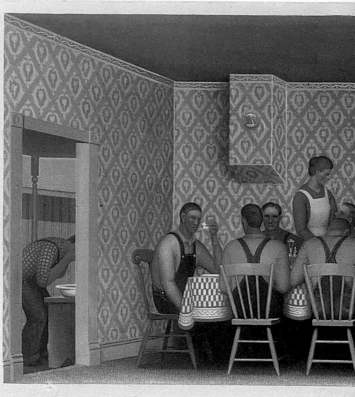

**Grant Wood**
*Daughters of Revolution*

1932
oil on masonite, 20 × 40
(50.8 × 101.6 cm)
Cincinnati Art Museum,
Cincinnati, Ohio

With irony and subtle
sarcasm—and showing an
almost maniacal attention
to detail—Wood presents
three members of the
Daughters of the American
Revolution, the group
founded in 1890 and today
counting nearly eight

hundred thousand members,
with its headquarters in
Washington, D.C. Wood
portrays the three elderly
women, one proudly
displaying a teacup, grouped
patriotically in front of the
famous, and quite theatrical,
painting by Emanuel Leutze

of *Washington Crossing
the Delaware* (1850),
a symbolic image that
glorifies the American
Revolution.

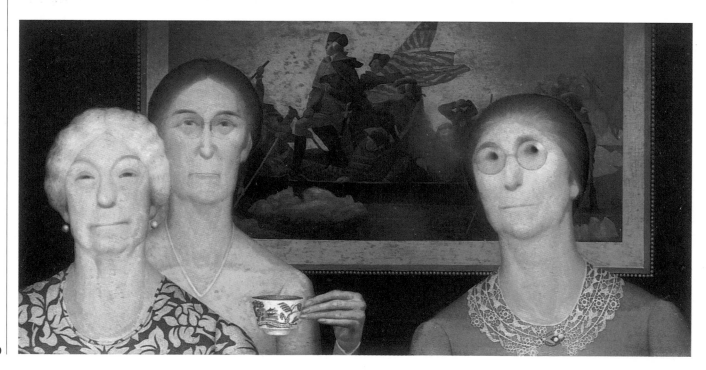

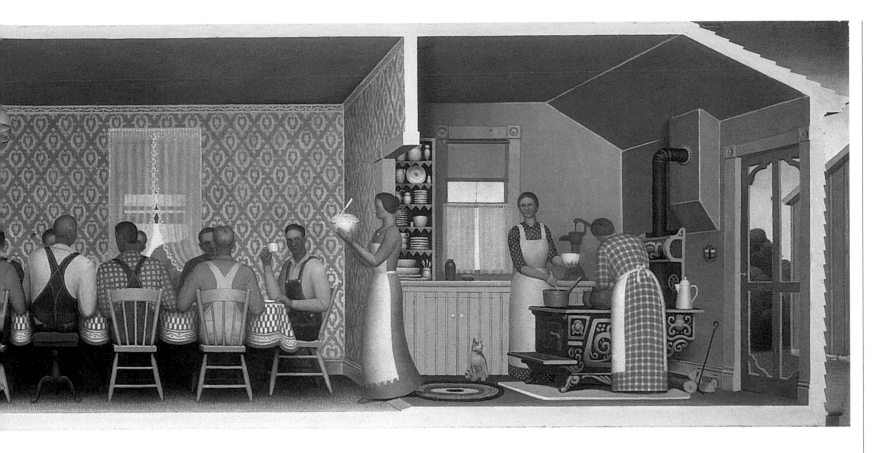

**Grant Wood**
*Sentimental Ballad*

1940
oil on masonite, 24 × 50
(61 × 127 cm)
New Britain Museum
of American Art,
Connecticut

*American Gothic* earned
Wood enormous public
and critical approval;
in 1934 *Time* magazine
called him the leading
philosopher of regionalism,
the new style of American
realist painting that
included the work of John
Steuart Curry and Thomas

Hart Benton. In 1940 the
art dealer who represented
Wood made a deal with the
Hollywood producer
Walter Wanger to send
Wood and eight other
artists to the set of the
John Ford film *The Long
Voyage Home*, based on short
plays by Eugene O'Neill.

The purpose of the trip is
publicity. The artists are to
make paintings of various
scenes from the film.
*Sentimental Ballad*, painted to
look like a photographic
still, is based on one of the
final scenes, set in a pub;
drunken seamen (from left
to right: John Qualen, John

Wayne, Thomas Mitchell,
Joseph Sawyer, David
Hughes, and Jack Pennick)
become emotional while
singing to a relative (the
seated Barry Fitzgerald).
Wood's image enjoyed
great success and was
reproduced in many
newspapers and magazines.

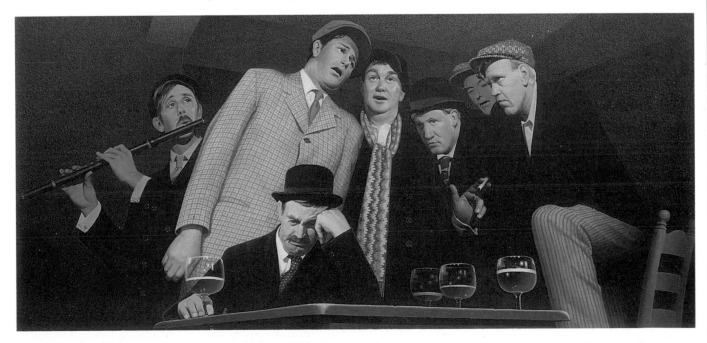

221

# William Gropper

*New York, 1897–*
*Manhasset, New York, 1977*

A highly talented painter and cartoonist, William Gropper studied under Robert Henri and George Bellows at New York's Ferrer School from 1912 to 1915. In 1917 he began work as a designer and cartoonist for the *New York Tribune*, soon working for other dailies and magazines, including *The New Yorker*, *Vanity Fair*, the *New York Post*, and the *New Masses*. Gropper started painting in 1921 and had his first solo show in 1936. In 1938 he dedicated himself to mural painting, making a painting for the Department of the Interior in Washington, D.C. He later took a trip to war-devastated Europe, bringing back a detailed and touching report. In 1947 he began teaching at the American Art School in New York. The realist vision of his earliest works soon gave way to a deeper style with which he expresses biting criticism of contemporary society and the hypocrisy of its political leaders. In timely images imbued with human compassion, Gropper directed his attention primarily at the lower levels of society; with empathy and incisiveness, and using a style that often touches on caricature, he presents the American society of the depression and postwar years.

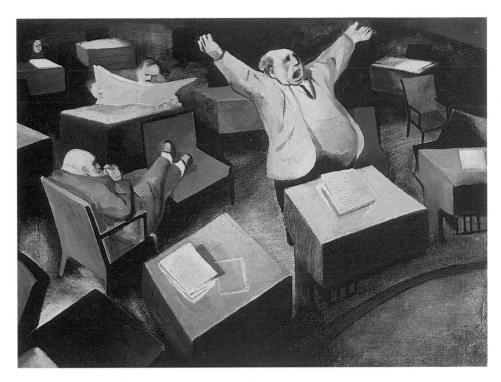

**William Gropper**
*The Senate*

1935
oil on canvas, 25.1 × 33.1
(63.8 × 84.2 cm)
Museum of Modern Art,
New York

With direct, essential realism and pointed sarcasm supported by a wonderful talent for simplifying the image, Gropper expresses his lack of faith in government leaders, in this case presenting a scene of several senators busy doing many things other than taking care of the nation.

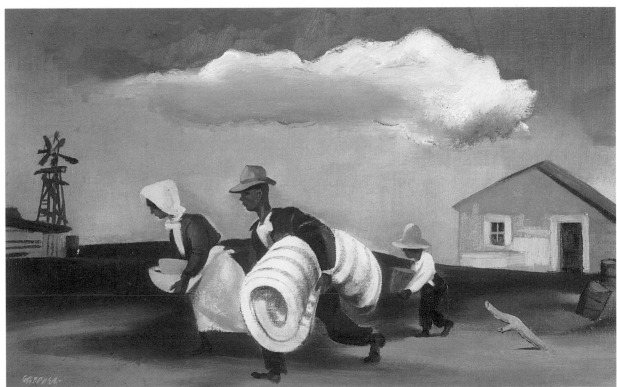

**William Gropper**
*Migration*

c. 1932
oil on canvas, 23.7 × 35.8
(60.3 × 91 cm)
Arizona State University
Museum of Art, Tucson

Here Gropper shows the effects of the Great Depression on American rural communities. Carrying their few belongings, a family of farmers is forced by extreme poverty to leave their home in an image that became emblematic of the conditions of the lower classes during the years of the Depression. The artist uses a rapid, abbreviated style, with simple but essential forms, almost like those of a cartoon, to deliver the message more directly and effectively.

# Philip Evergood

*New York, 1901–*
*Bridgewater, Connecticut, 1973*

Together with Ben Shahn, Evergood was one of the leaders of social realism. Although born in the United States he lived in England from 1909 to 1923, where he studied at the Slade Art School of London. He was back in New York in 1923 only to return to Europe, staying in Paris from 1924 to 1926, taking classes under André Lhote at the Académie Julian and exhibiting at the Salon d'Automne in 1924. During those years he also visited Spain, where he was deeply affected by his encounter with the visionary work of El Greco. On his return to the United States he made a series of murals, including *The Story of Richmond Hill*, in the Queens Public Library (1936–37). Evergood's peculiar and poetic language combines realism and fantasy, the lucid analysis of social situations and the dramatic state of the urban masses with a sense of the unreal and the imaginary. The paintings he made at the end of the 1940s present a virtuosic linear style, an often illogical or unnatural use of space, and a special attention to biblical and mythological symbolism.

**Philip Evergood**
*The Future Belongs to Them*

1938–53
oil on canvas, 60 × 40
(152.5 × 101.7 cm)
Private collection

Deeply aware of the social problems of the time, Evergood created a style halfway between social realism and magical realism; his works are distinguished by their elegant and oddly expressive distortion of pictorial language, a style not unlike the raw, allegorical verism of the German painter Max Beckmann. *The Future Belongs to Them* is an allegory of racial integration, a confident hymn to the resolution of all problems related to the coexistence of differing races and cultures. The artist uses a loose, fantasy-driven line to suggest an unreal and illogical space, an expression of an intimate and poetic world.

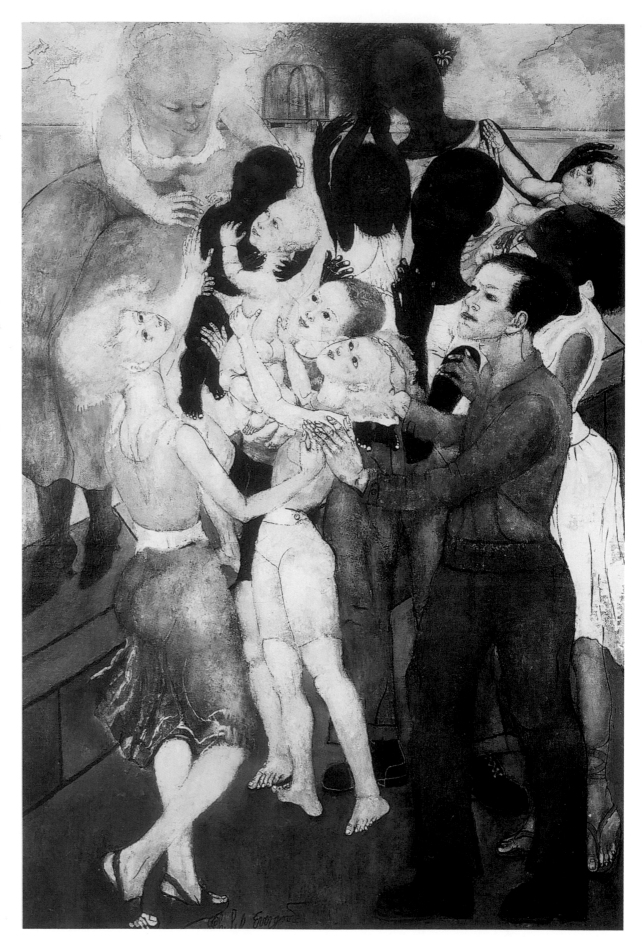

# Ben Shahn

*Kovno, Lithuania, 1898–New York, 1969*

Shahn is one of the most famous artists of the social realism movement of the 1930s. Born in Lithuania, he arrived in New York in 1906 and began working as an apprentice lithographer in 1913. From 1919 to 1922 he studied at the National Academy of Design and was in Europe from 1924 to 1925, going back in 1927 to 1929. In Europe he encountered the works of the expressionist painters George Grosz and Otto Dix. The dramatic realism of their expressive language, incisive and essential, and their subjects related to urban and political realities had a deep influence on Shahn's later work. Back in New York, Shahn dedicated himself to social and political themes, using a graphic style and a caustic point of view to deal

with themes of social protest, such as government mistreatment of innocent victims. The series of works he dedicates to the Sacco and Vanzetti trial (1931–32) became famous for its dramatic intensity. His later works, inspired by deep human compassion and not weighed by propaganda, are intense and almost surreal presentations of the loneliness of humans and the conditions of poverty and abandonment found at the lower levels of society, among poor immigrants and the displaced. In 1933 Shahn worked with the Mexican painter Diego Rivera on the mural entitled *Man at the Crossroads* for the RCA Building, part of Rockefeller Center in New York, which was destroyed before being completed because it included a portrait of Lenin. He later worked on murals for the Federal Art Project. A photographer of great talent,

Shahn worked for the Farm Security Administration from 1935 to 1938, taking photographs of impoverished areas in Ohio and the surrounding states to document the effects of the Depression on the lower levels of rural America.

**Ben Shahn**
*Study for the mural painting in the Jersey Homesteads*

c. 1936
tempera on panel,
19.5 × 27.5
(49.6 × 69.9 cm)
Private collection

This is a preparatory study for a mural commissioned by the federal administration for the Jersey Homesteads, a workers' community in New Jersey (now Roosevelt, New Jersey). The experience of working alongside the Mexican muralist Diego Rivera marked Shahn's formative years, and in this work he indicates that he has developed his own expressive language. To the upper left are the bodies of Sacco and Vanzetti in their coffins.

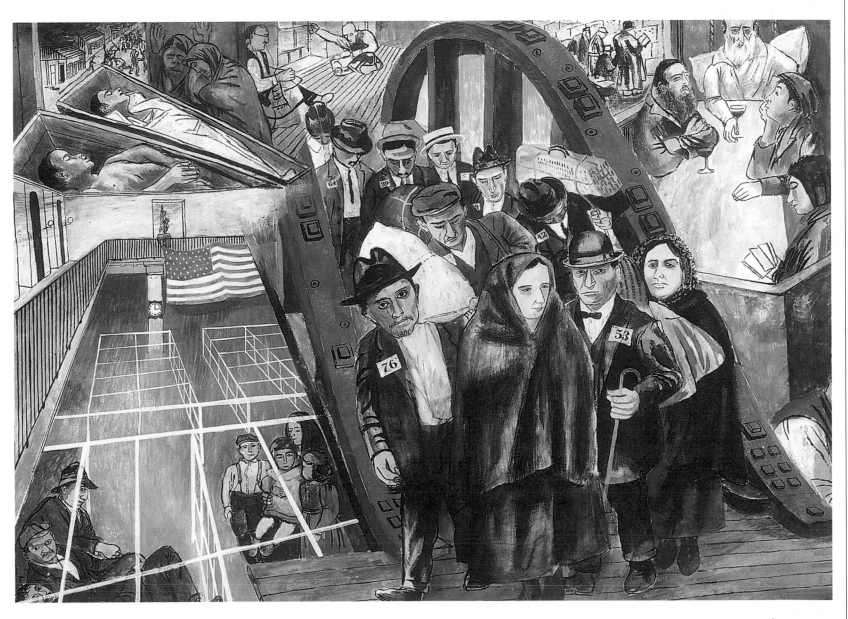

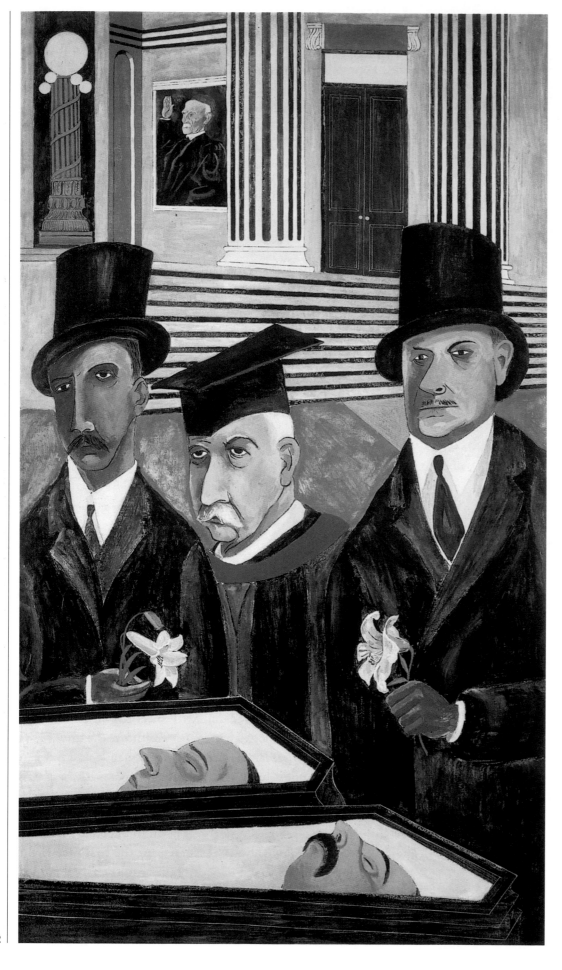

**Ben Shahn**
*The Passion of Sacco
and Vanzetti*

1931–32
tempera on canvas,
84.5 × 48
(214.6 × 121.9 cm)
Whitney Museum of
American Art, New York

Between 1931 and 1932
Shahn made a series of
works dedicated to Nicola
Sacco and Bartolomeo
Vanzetti and their famous
trial, which occupied the
front pages of newspapers
worldwide, awakening
great clamor in the
United States along with
international protests.
The two Italian-American
anarchists were found
guilty of murder in 1921
and sentenced to death,
although much of the
evidence against them was
discredited. Because of
appeals and criticism of
the conduct of the trial,
a three-man committee
was appointed to examine
the judicial procedure;
in August 1927 the
committee approved
the verdict, and Sacco and
Vanzetti were executed
by electric chair. In Shahn's
works, the two anarchists
are presented as innocents
made martyrs by rushed
and partial judgment
and by the antiradical
climate of the time.
In this famous work,
designed as an intense
moral condemnation,
the artist uses a terse line
and follows an essentially
expressionist style to
present the three members
of the commission,
portrayed sarcastically
in positions alongside the
two coffins, holding in
their hands lilies, symbolic
of death and resurrection.

**Ben Shahn**
*Italian Landscape*

1943–44
tempera on paper,
27.6 × 36
(70 × 91.4 cm)
Walker Art Center,
Minneapolis, Minnesota

This powerfully emotive
image of desolation
and death presents an
Italian landscape during
World War II. Near
a bridge destroyed by
bombardment, and beneath
a sadly colorless sky,
a funeral takes place,
with women mourning
their dead. Shahn employs
a purposefully simplified,
archaic style to express the
intensity and spontaneity of
his emotional involvement
in this human drama.

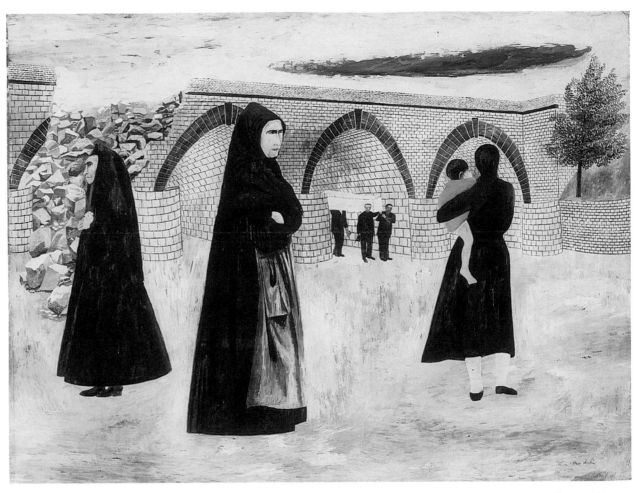

**Ben Shahn**
*Four-Piece Orchestra*

1944
tempera on masonite
18 × 23.7
(45.7 × 60.1 cm)
Museo Thyssen-
Bornemisza, Madrid

Shahn uses a linguistically
tense and unsettling
pictorial language,
immediate and spare,
to present this rustic
orchestra composed
of four instruments.
The three musicians,
busy playing, intent
on their performance,
have absorbed, grave
expressions. The natural
world around them is
bare and sad, symbolic
of a reality without
hope of deliverance.

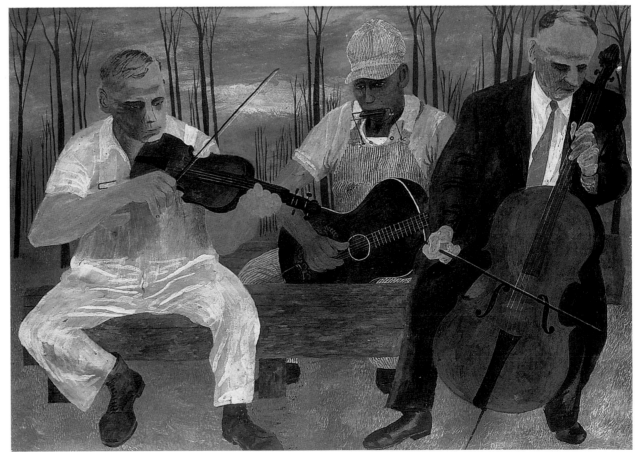

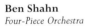

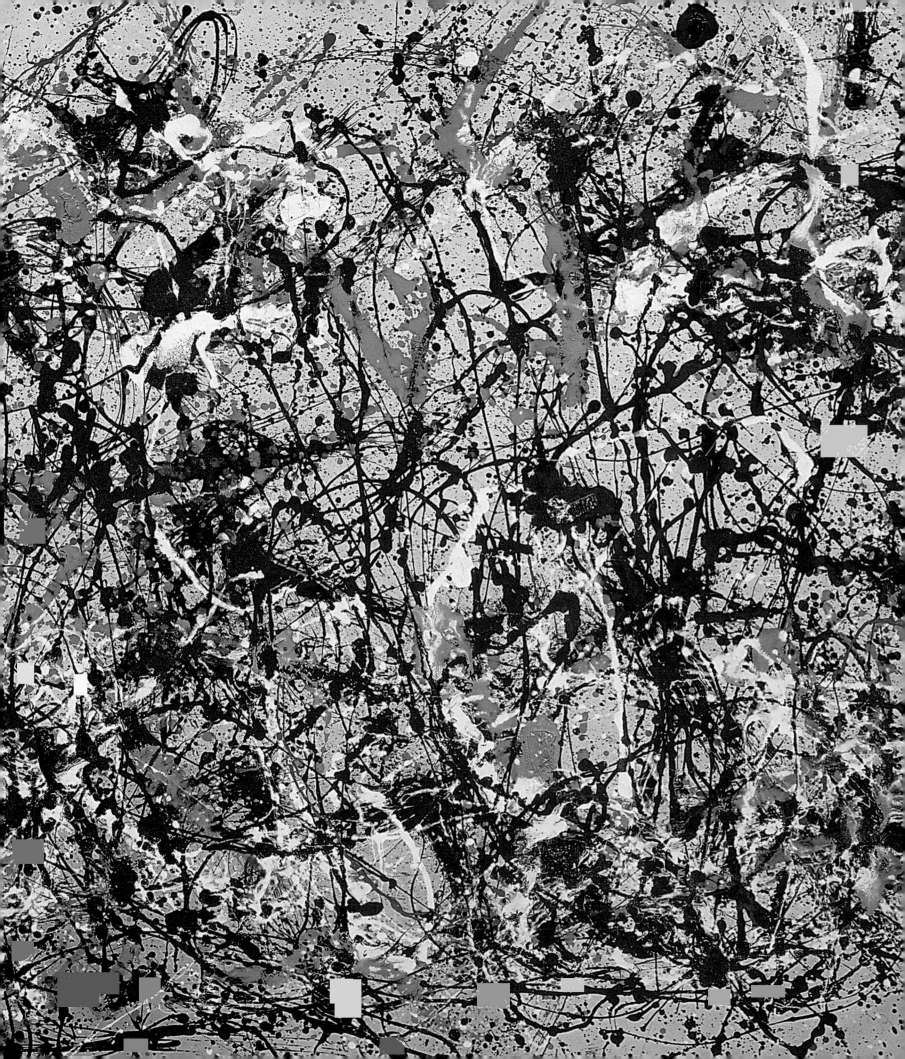

**Jackson Pollock**
*Enchanted Forest*

1947
oil on canvas, 87 × 44.9
(221 × 114 cm)
Peggy Guggenheim
Collection, Venice

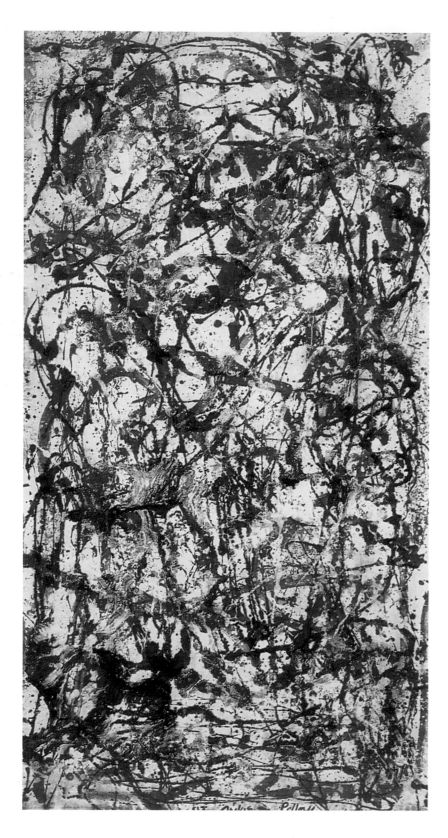

From the 1930s to the 1940s New York replaced Paris as the center of the art world. Many European artists moved to the United States and carried on their work in such settings as the New School of Social Research in New York, Black Mountain College in North Carolina, and the New Bauhaus in Chicago. Those same places saw the progressive affirmation of talented young Americans and the eclipse of European supremacy.

Roosevelt's New Deal marked the beginning of important government support for young artists. The Federal Art Project, in place from 1935 to 1943, employed artists, commissioned murals, sponsored shows, organized design laboratories based on the model of the Bauhaus, and encouraged the kind of audacious experimentation that would elsewhere receive only limited support. Such was the case with abstract art, which by the end of the 1930s was the only alternative to regionalism, by then growing anachronistic, and to social realism, the style promoted by the more left-leaning art critics. In 1936 the American Abstract Artists (AAA) association was founded with a four-point program: the unity of all American artists, the exhibition of their works, the education of the public, and the use of interdisciplinary approaches. Viewed in many ways as subordinate to regionalism and social realism, the AAA had only limited impact, but it was of unquestioned historical importance since it kept active the discourse with modernism.

The 1939 New York World's Fair included the American Art Today pavilion, which had the avowed aim of offering equal time to the various movements in American art. Even so, abstract art was given only marginal attention, far larger space going to the figurative production of the first generation of modernists, strongly influenced by surrealism, which had made its appearance in the United States at the beginning of the century. Surrealist automatism, although in a form far different from the "psychic" version preached by André Breton, also showed up in abstract expressionism, also known as action painting (as it was termed by the

critic Harold Rosenberg) and gestural painting. The dynamics of gestural painting represent a fundamental break with tradition. In it, painting becomes a sort of private writing used by the artist, who in a rapid gesture fixes a moment of time to the canvas. The painting thus comes to symbolize an event, an episode in the drama of the artist's ongoing self-exploration.

Looked at in retrospect, Jackson Pollock's 1943 one-man show assumes the character of an announcement of a new kind of American painting. The creative act becomes the fundamental expressive moment; what counts is not the image taking shape in the artist's mind but the development of that image as it springs from his or her hand. During that process the artist cannot help but give in to a certain display of virtuosity, inviting spectators to admire his or her improvisational skills as well as his or her courage for taking such a dramatic risk, putting the most intimate resources on the line, so to speak, during a brief moment of profound intensity. This also applies to Willem de Kooning, who attributed a decisive role to the rapidity of execution and to the personal artistic gesture.

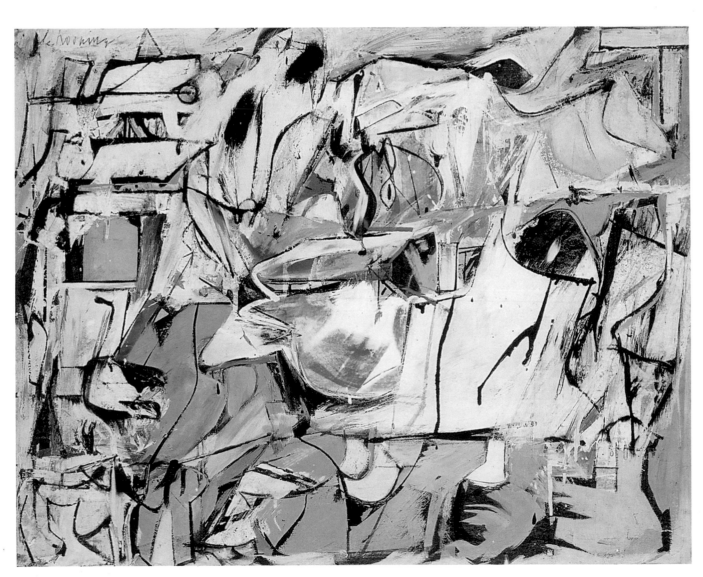

**Willem de Kooning**
*Asheville*

1948
oil and enamel on cardboard mounted on panel,
26.5 × 32
(67.3 × 81.2 cm)
Phillips Collection,
Washington, D.C.

**Mark Tobey**
*Written over the Plains*

1950
oil and tempera on
masonite, 30.1 × 40
(76.54 × 101.6 cm)
San Francisco Museum
of Art, San Francisco

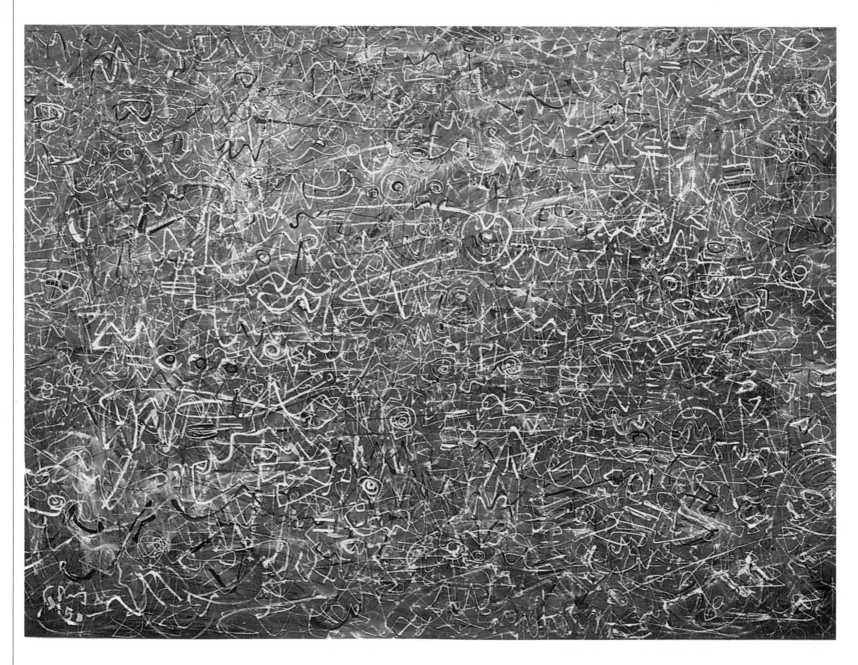

Mark Tobey is considered a precursor of abstract expressionism, although his highly personal artistic vision, permeated with Eastern mysticism, prevents him from fitting into any rigid stylistic classification. Late, and in some measure legendary, was Franz Kline's arrival at abstraction; he convinced himself of the self-sufficiency of the sign from the original idea by taking a drawing of a rocking chair and projecting its enlarged image onto a canvas so that it spreads beyond the borders of the canvas, becoming an abstract design. His abstract paintings enjoyed an extraordinary season between 1949 and 1950, during which he proved himself the action painter par excellence: variously oriented black spatial guidelines contend with white backgrounds for the control of the surface. There was nothing definitive about his use of black and white, however, and around 1958 Kline returned to polychrome painting, but with uncertain results. With his "chromatic abstraction," Mark Rothko captures the viewer with masses of transparent floating chromatics. Far different are the dense, impenetrable surfaces created by Clyfford Still, who reached his greatest expression toward the end of the 1940s with violent, aggressive paintings characterized by jagged areas, anomalous colors that drift across the canvas, faithful only to an upward imperative. A member of the same Federal Art Project section as Pollock, William Baziotes went through a surrealist automatism period during which he performed such procedures as immersing canvases in water.

Among the abstract expressionists of the second generation, Sam Francis returned to Still's color fields, demonstrating a balanced decorative style. In the field of "geometric abstraction," Kenneth Noland and Frank Stella distinguished themselves. The former debuted in 1956 with irregular concentric circles of color placed at the center of square canvases like bull's-eyes; the latter, using shaped canvases painted in monochromatic bands or with flat colors, rose to become the most original member of the movement during the early years of the 1960s.

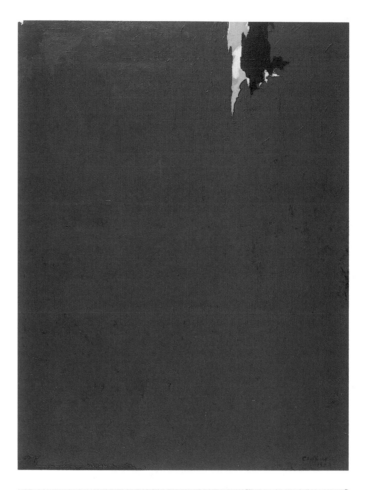

**Clyfford Still**
*1953*

1953
oil on canvas, 92.9 × 68.5
(236 × 174 cm)
Tate Gallery, London

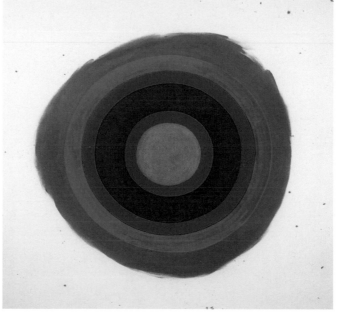

**Kenneth Noland**
*Song*

1958
synthetic polymer
on canvas, 65 × 65
(165 × 165 cm)
Whitney Museum of
American Art, New York

**Jackson Pollock**
*Stenographic Figure*

1942
oil on linen, 40 × 56
(101.6 × 142.2 cm)
Museum of Modern Art,
New York

Although Pollock's early
works were still figurative,
the influence of the totems
used by Navaho Indians
and their ritualistic sand
paintings pushed him
toward the reduction of
images and thus along the
route to abstraction.

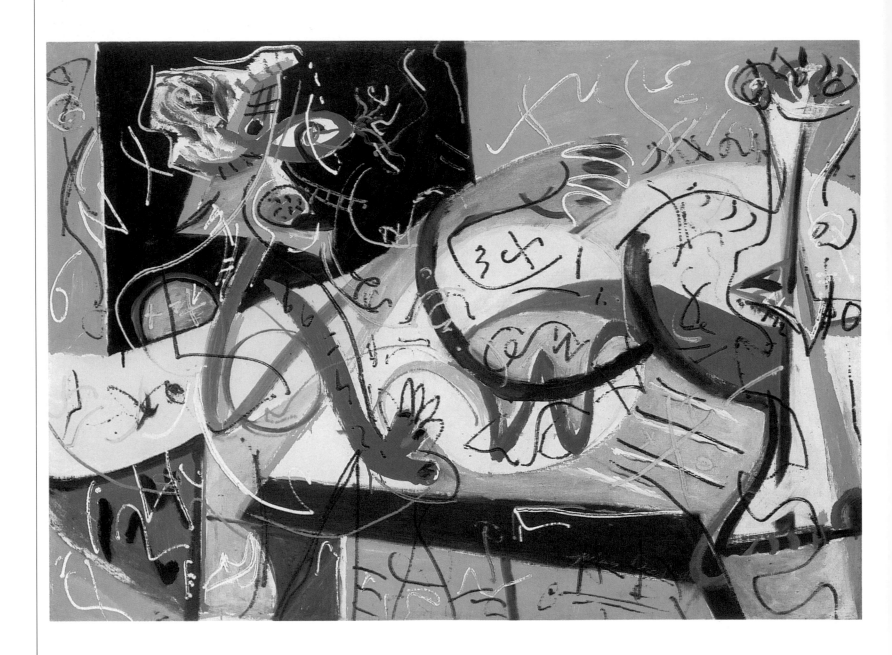

**Jackson Pollock**
*Shimmering Substance*

1946
oil on canvas, 30 × 24.3
(76.3 × 61.6 cm)
Museum of Modern Art,
New York

Pollock's success was
based on the fact that
he freed painting from
all ties to other disciplines,
transforming it into
a highly personal means
of self-expression.

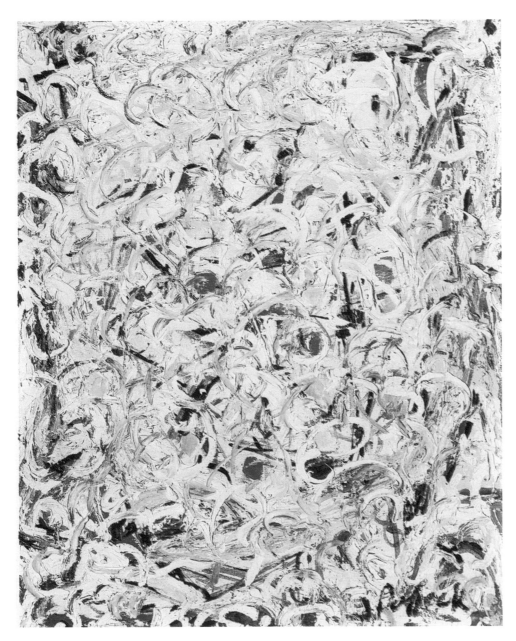

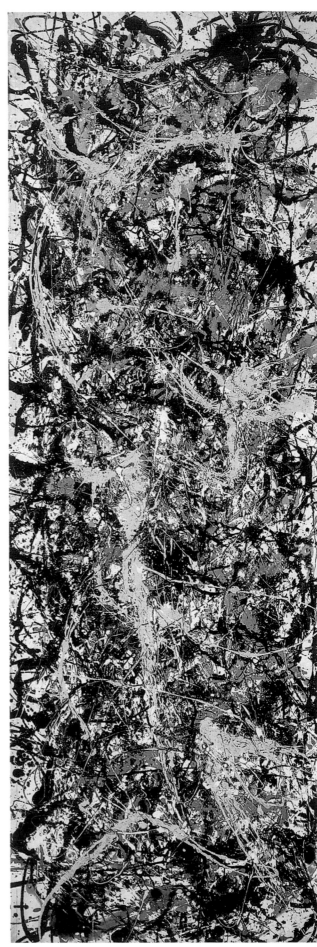

**Jackson Pollock**
*Number 2*

1950
oil, lacquer, Duco,
aluminum paint, and
stones on canvas, 113 × 36
(287 × 91.5 cm)
Fogg Art Museum, Harvard
University Art Museum,
Cambridge, Massachusetts

Pollock made an
essential contribution
to contemporary
painting by enriching
its vocabulary and also
by changing its
fundamental language.

**Jackson Pollock**
*Painting*

1948
vinyl on paper,
24 × 31.5
(61 × 80 cm)
Centre Georges Pompidou,
Musée National d'Art
Moderne, Paris

The works Pollock
made during the mature
phase of his artistic
production are never
casual, nor are they
merely expressions
of his originality.
No one put more solid

effort into mastering
the precepts and
conventions of art,
and no one worked
harder to acquire
the competency to
apply them.

**Jackson Pollock**
*Number 27*

1950
oil on canvas, 49 × 106
(124.5 × 269.2 cm)
Whitney Museum of
American Art, New York

Pollock dedicated his
short life to the search
for a truth completely
free of the myths of
American civilization.
Unlike so many other
American artists, Pollock
did not look to Europe
but accepted the risks
of working in isolation.

**Jackson Pollock**
*Grayed Rainbow*

1953
oil on canvas, 72 × 96.1
(182.9 × 244.2 cm)
Art Institute of Chicago

Pollock made his way into
his canvases physically,
using his own gestures to
guide the dripping paint
and thus creating a new
dynamism centered on
his own emotions.

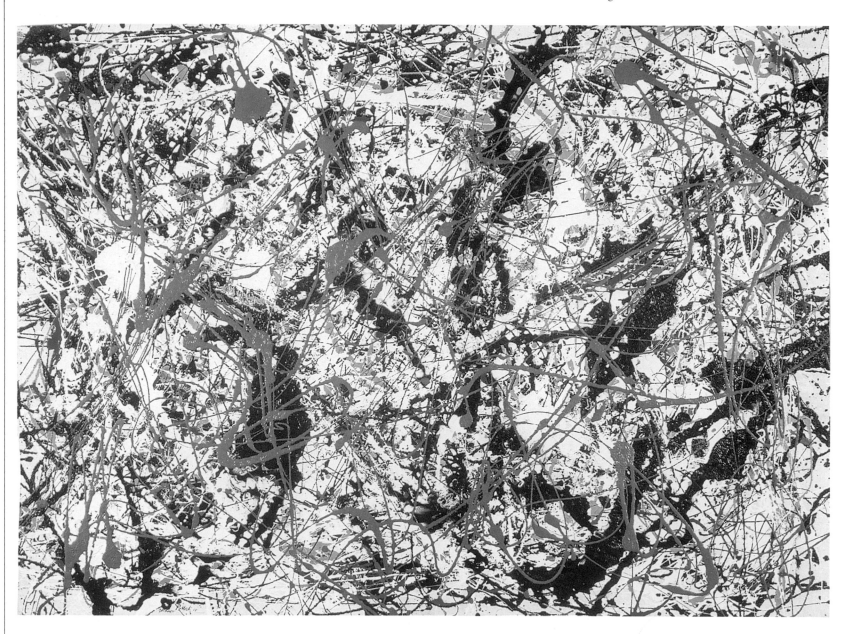

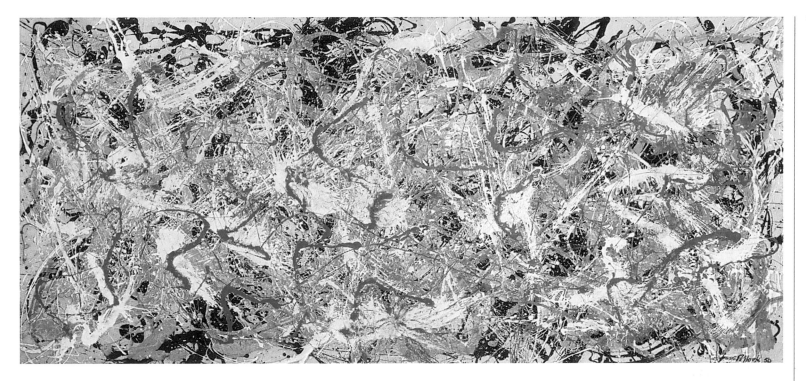

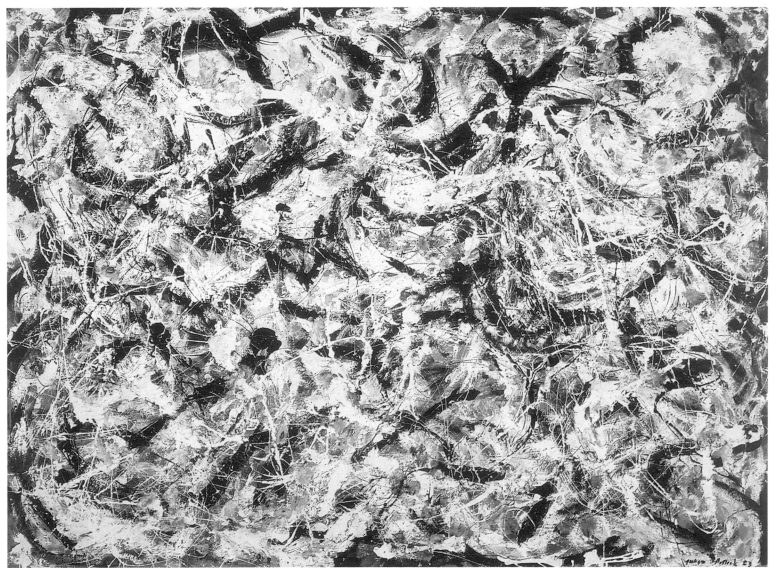

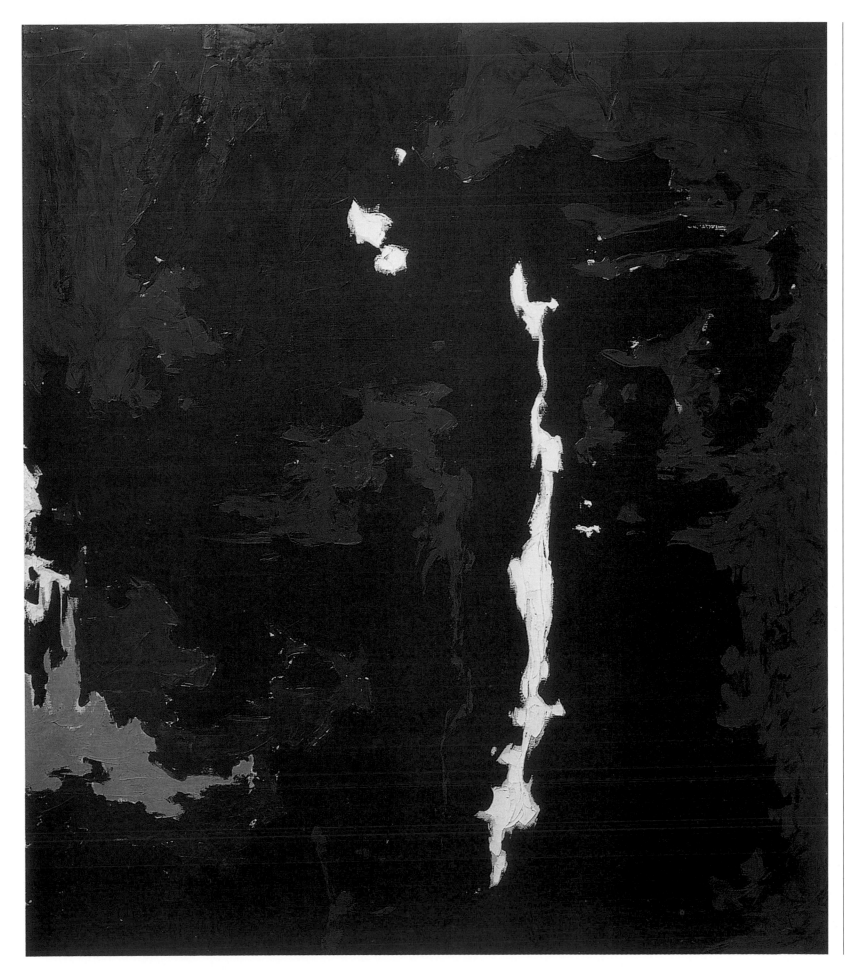

# William Baziotes

*Pittsburgh, 1912–New York, 1963*

The stylistic roots of the art of William Baziotes grew from European surrealism, many exponents of which took refuge in New York during World War II and entered the circle of Peggy Guggenheim.
Baziotes studied at the National Academy of Design in New York from 1933 to 1936; among his fellow pupils was the portraitist Leon Kroll. He was employed as a teacher and painter by the Federal Art Project and met surrealist émigrés in New York; after encountering the Chilean painter and surrealist Guillermo Matta he began experiments with surrealist automatism. Following his first personal show at the Art of This Century Gallery, in 1944, his style underwent a transformation.
He simplified the forms, adhering to the so-called biomorphic surrealism favored by Joan Miró and André Masson. The exploration of this technique, combined with surrealist automatism, offered Baziotes the opportunity to approach the canvas with a new kind of inspiration, similar in its urge for spontaneity to Pollock's impromptu energy. Baziotes's romantic sensibility is expressed delicately, using fluid, luminous colors that suggest the play of light and shadows through layers of water or the rippling movements of underwater life forms.
In 1948 Baziotes and Rothko were among the founders of the Subjects of the Artist school in New York.

**William Baziotes**
*Dusk*

1958
oil on canvas, 60.4 × 48.2
(153.3 × 122.5 cm)
Solomon R. Guggenheim
Museum, New York

Baziotes's early works involve fantastic or mythological creatures, giving way in later works like this to dreamlike images suspended against an indistinct cloudy background. The colors, at the same time dark and brilliant, are covered with successive layers of tone to give the composition its sense of an unreal dimension.

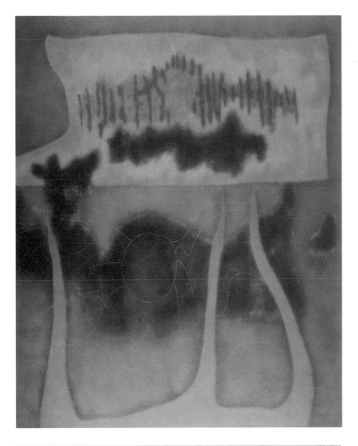

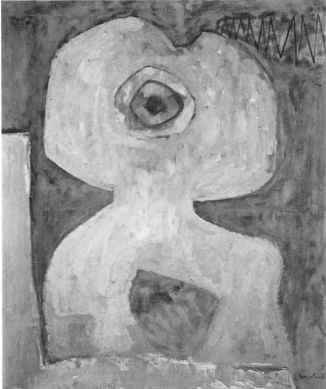

**William Baziotes**
*White Bird*

1957
oil on canvas, 60 × 48
(152.4 × 122 cm)
Albright-Knox Art Gallery,
Buffalo, New York

**William Baziotes**
*Pompeii*

1955
oil on canvas, 60 × 48
(152.4 × 122 cm)
Museum of Modern Art,
New York

**William Baziotes**
*Cyclops*

1947
oil on canvas, 48 × 40.1
(122 × 102 cm)
Art Institute of Chicago

**Frank Stella**
*Effingham I*

1967
acrylic on canvas,
128.7 × 131.3
(327 × 333.5 cm)
Stedelijk Van Abbe
Museum, Eindhoven

The innovative force
behind Stella's art is
its way of asserting its
presence as a complete
reality. Made on canvases
in unusual geometric
shapes, his paintings
present themselves
as objects.

**Frank Stella**
*Spectrum*

1961
acrylic on canvas, 8 × 16
(20.3 × 40.7 cm)
Private collection

Following meticulous
symmetry, Stella divides
the canvas into two series
of six squares each, the
squares inserted one inside
the next in increasing size;
for their part, the colors,
too, are inserted in the
squares in inverse order,
running from yellow
to black in one series,
vice versa in the other.

**Frank Stella**
*Khurasan Gate (Variation) I*

1969
polymer on canvas,
96.1 × 285.4 × 3.1
(244 × 725 × 8 cm)
San Francisco Museum of
Modern Art, San Francisco

From pop art to graffiti

Roy Lichtenstein
*Whaam!*, detail

1963
acrylic on canvas,
67.7 × 160
(172.7 × 406.4 cm)
Tate Gallery, London

In the early years of the 1960s the expression pop art, the abbreviation of popular art coined in 1955 by the English scholars Leslie Fiedler and Reyner Banham to indicate the world of mass media, was applied to a new avant-garde movement distinguished by its intellectual adaptations of the languages of mass culture, from advertising images to comic books, from movies to television, from consumer products to fashion. Not by accident was the movement born in the United States, where the technological development and the consequent process of mass standardization have had their most extreme manifestations. In this way the action painting of the abstract expressionists, based on the artist's individual experience, was re-placed by an adaptation to artistic uses of the materials and modes of ordinary experience. With pop art, the approach to reality cannot be anything but social and collective.

The movement's international success was decreed by the Venice Biennale of 1964, where the exhibitors included Jasper Johns, Robert Rauschenberg, and Jim Dine, artists whose careers began in the 1950s with a reworking of the Dada language. Unlike the disputatious relationship that animated the historical Dadaists, these artists look on the object as an effective instrument for direct contact with the world. The label "New Dada" was first applied to Jasper Johns, on the occasion of his first one-man show at the Leo Castelli Gallery in New York in

**Jasper Johns**
*Flag*

1954–55
encaustic, oil, and collage on canvas mounted on board, 42.2 × 60.6 (107.3 × 154 cm)
Museum of Modern Art, New York

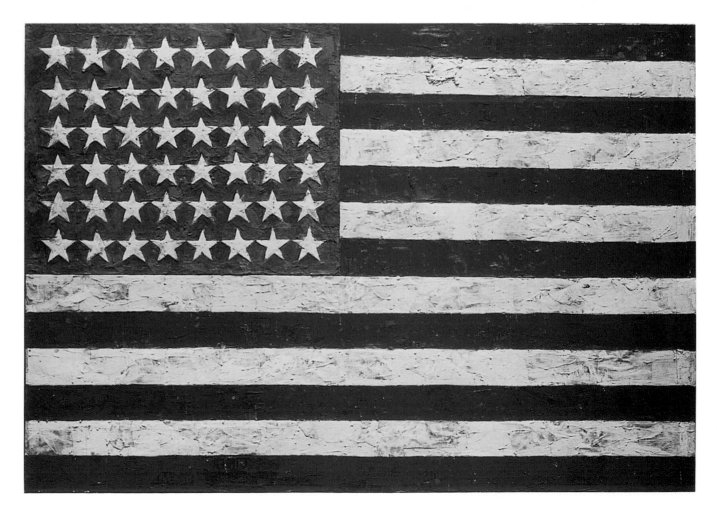

**Robert Rauschenberg**
*Retroactive II*

1963
oil and silkscreen ink
on canvas, 80 × 60
(203.2 × 152.4 cm)
Museum of Contemporary
Art, Chicago

Following the assassination
of John F. Kennedy
in November 1963,
Rauschenberg has used
images of the young
president delivering his
inaugural address of 1961
in many of his works.

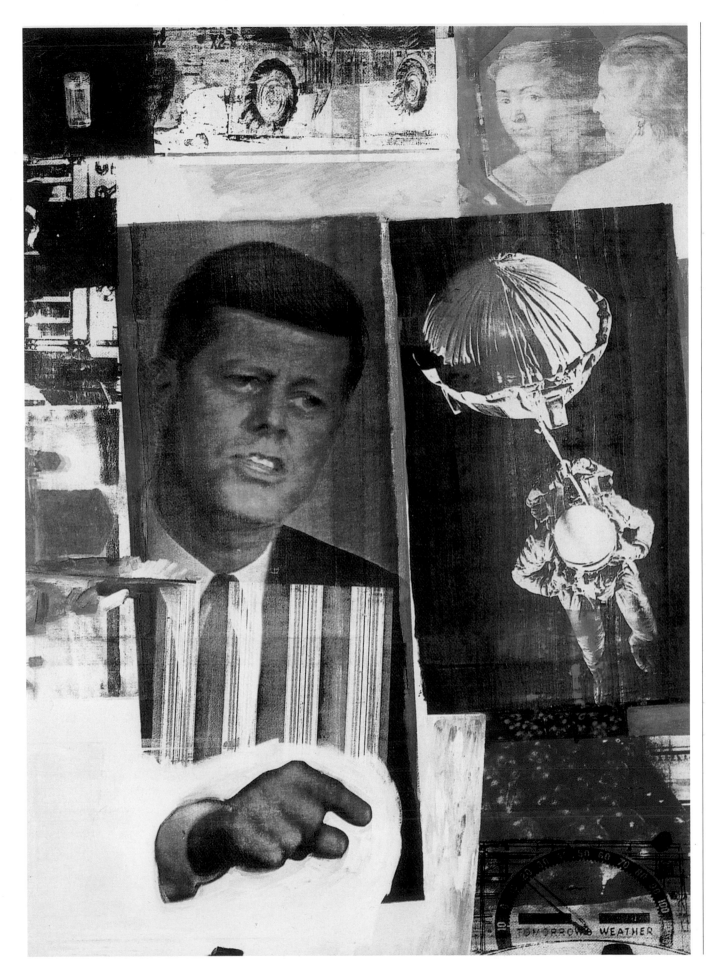

# Jim Dine

*Cincinnati, 1935*

Follower of Neodadaism but also influenced by Russian constructivism, in particular Ivan Puni, Dine worked out a pictorial language characterized by a highly personal relationship to the object, whether it is painted or, more often, applied directly to the canvas.

Dine arrived in New York in 1958 and held his first "happening" at the Judson Gallery the very next year. In 1962 he organized his first one-man show, causing quite a sensation: He exhibited *Green Suit* and *Flesh Tie*, a suit and tie painted following gestural art. Dine declared that his painting is made of objects that he intends to transfer to the canvas without changing or distorting them romantically, since what interests him is only their presence. The articles of clothing of his first works are soon joined by tools—saws, hammers, pliers, screwdrivers—all of them hung on the canvas, sometimes upside down, always in a way that forces them to show themselves off in an isolated, frontal presentation so as to create a face-to-face relationship between the viewer and the painting. The factor of perception takes on a central role. The act of seeing is neutral, but observation, while passive, hides an interrogating, scrutinizing tension that in some ways recalls the attitude of the detective faced with the photo of a suspect. More recently, Dine has preferred palettes and chromatic scales in which he shows himself treating color on the same level as an object.

**Jim Dine**
*Shoe*

1961
oil on canvas
Property of the artist

Exhibited at the Venice Biennale in 1964, this work is an eloquent simplification of Dine's pictorial procedure. At other times and places, artists use the object as a model, isolating it on the canvas and presenting it using the tools of painting; in this case, the object is absent, and what remains is its trompe l'oeil imitation.

**Jim Dine**
*White Suit*

1964
mixed media,
72 × 36.2 × 3
(183 × 92 × 7.5 cm)
Stedelijk Museum,
Amsterdam

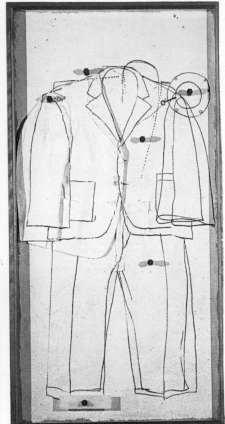

**Jim Dine**
*Night Supply*

1972–73
mixed media on canvas,
28.3 × 42.5
(72 × 108 cm)
Private collection

**Roy Lichtenstein**
*Temple of Apollo*

1964
oil and magna on canvas,
93.9 × 128
(238.6 × 325 cm)
Pulitzer Collection,
Saint Louis, Missouri

Using patterns of colored
circles that imitate the
dots of the Benday process,
Lichtenstein reproduces
the fabric of the
mechanical method
from which the image
has been drawn,
progressively approaching
the depersonalization of
the subject. The manual
operation is so sophisticated
that it becomes invisible; in
this case the representation
of a classical temple takes
on the appearance of a
comic-strip reproduction.

**Roy Lichtenstein**
*Big Painting VI*

1965
oil and magna on canvas,
91.7 × 129.1
(233 × 328 cm)
Kunstsammlung
Nordrhein-Westfalen,
Düsseldorf

Lichtenstein's long and
elaborate experiments
with the use of Benday
dots met success in the
1960s, when the motif
triumphed. This is
from the famous series
from 1965 in which
brushstrokes become an
icon of antiexpressionism.

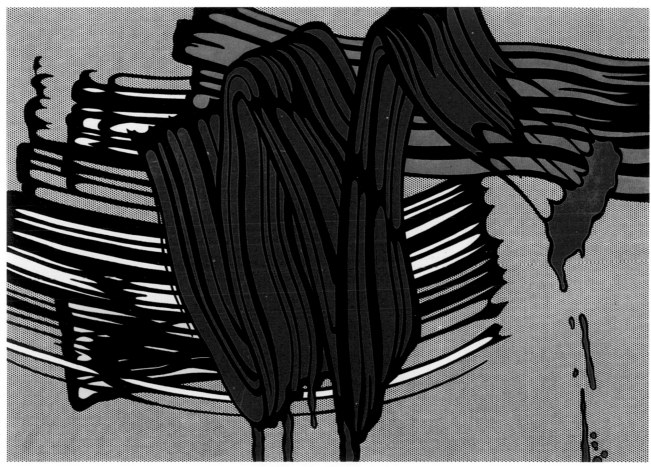

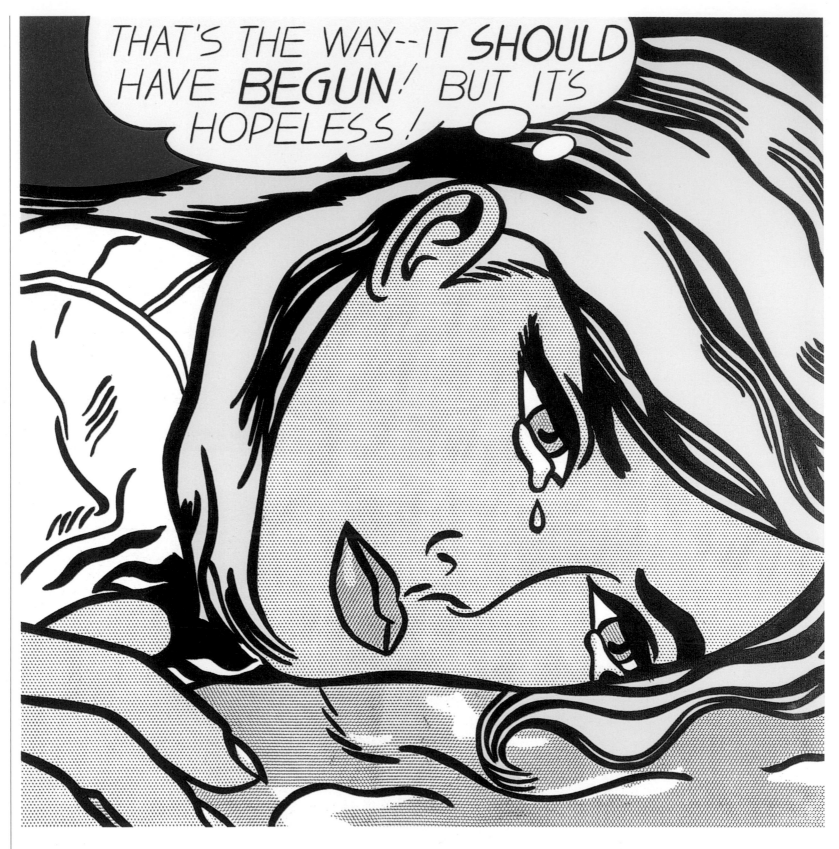

**Roy Lichtenstein**
*Hopeless*

1963
oil and acrylic on canvas,
43.9 × 43.9
(111.5 × 111.5 cm)
Kunstmuseum, Basel

The central figure, enlarged and presented close-up and two-dimensional, makes clear the formal values—such as the clarity of the outlines, the pointillist geometry of the screen dots, and the clean application of the color—along with the attendant loss of narrative values. The lines and the orderly dots, applied in the area of the face and other parts of the image, interrupt the surface continuity, making possible chromatic shading with results similar to those made using halftones or compound colors.

**Roy Lichtenstein**
*Artist's Studio, "The Dance"*

1974
oil and magna on canvas,
96 × 128
(243.7 × 325 cm)
Collection of Mr. and Mrs.
S.I. Newhouse, Jr.,
New York

In the beginning of his
career Lichtenstein
recycled images from daily
life; in his more mature
period he turned to
masterpieces of world art
for his inspiration. In this
painting the presence of
Matisse is quite literal;
in fact, Matisse's *The Dance*
serves as the background
to elements that
Lichtenstein recycles
from one of his own
paintings, *Sound of Music*,
from 1964.

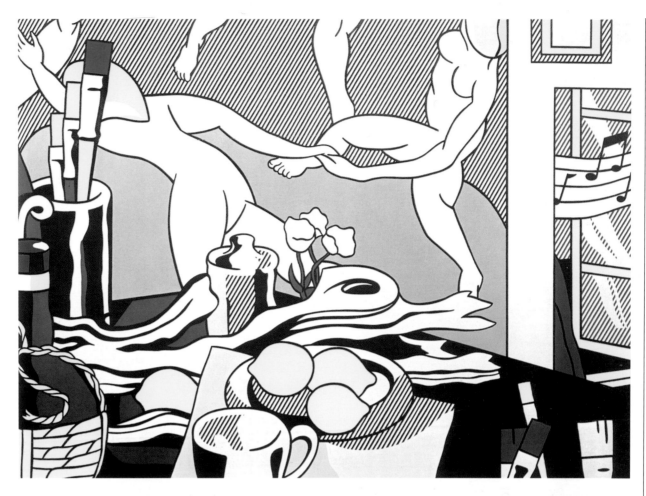

**Roy Lichtenstein**
*Forest Scene*

1980
oil and magna on canvas,
96 × 128
(243.7 × 325 cm)
Private collection

Between 1979 and 1980
Lichtenstein dedicated a
series of paintings to the
history of expressionism
and its leading exponents.
This painting echoes the
works of the German
expressionist painter
Franz Marc, particularly
his *Figures and Animals in
Woods*, which Lichtenstein
reproduces in a more
rigid and angular style.